TALES OF THE

Russian River

Published by The History Press
Charleston, SC 29403
www.historypress.net

Copyright © 2013 by John C. Schubert
All rights reserved

All images courtesy John C. Schubert collection unless otherwise noted.

First published 2013

Manufactured in the United States

ISBN 978.1.60949.626.5

Library of Congress CIP data applied for.

Dedicated to my granddaughters, Jasmine, Sabrina, Johnna and Heather

CONTENTS

FOREWORD

The Russian River (better known to the locals as "The River") meanders one hundred miles from the northern headlands in south Mendocino County to the mouth in Jenner, where it merges into the mighty Pacific Ocean. For over one hundred years, vacationers and vagabonds have set foot and marveled in its grandeur; from the mighty *Sequoia sempervirens* redwood forest to the murky green waters, the Russian River has been home to many characters. However, there is a certain type who is happiest amongst these redwoods and the lazy green river. This person can be described as simple, charming, neighborly and old-fashioned while possessing a deep love and stewardship for the surrounding nature. This person's face is well known to the townsfolk, and his voice is immediately recognized from the first sound. This person knows the town's story, possesses an arsenal of corny jokes and remembers the events that have happened, whether major or minor, as well as the people these events affected. Any town across America without a person such as this is a town without its heart because this person has made loving his town his own raison d'être. For the town of Guerneville, California, this person is John Schubert.

John spent his childhood summers in Guernewood Park at his grandfather's cabin on Old Monte Rio Road. While born just three years after the removal of the railroad, John experienced the tail end of what is better known as the "glory days" of "Russian River Vacation Wonderland." However, he wouldn't call Guerneville home until 1956. It was then that he began developing his real interest in the area's history. Working as a deputy

sheriff for Sonoma County Courts, he'd spend many lunch hours perusing the archives at county offices in Santa Rosa for his book, *Guerneville Early Days*, a feat that would take him thirty years to complete. He became known around the local digs such as Pat's Restaurant and through the Sonoma County Sheriff's Office as "the history guy" and was on the receiving end of numerous historical donations (mainly old postcard collections) and the ear to many stories. Over the years, John was able to secure (and, in some cases, rescue) hundreds of documents and postcards, further preserving the area's history.

In the 1970s, he began ventures in writing, mainly poetry and historically informative articles for the Sonoma County Historical Society's newsletter, *The Historian*. In the late '70s, he landed a small column in Guerneville's local paper, known as (what else?) *The Paper*. His column contained numerous stories about historical events (contained herein this book), but what set his column aside from the rest is his character, the Ol' Timer. Conjured completely in his mind, Ol' Timer became John's version of the relic resident of town; Ol' Timer was just old enough to remember the mud roads and trains but lived long enough into the 1970s to share his many stories with the author. Inspiration for Ol' Timer came from the local old-timers whom John knew as a child, such as Clare Harris, owner of Johnson's Beach, or C. Raymond "Buster" Clar. The charisma of Ol' Timer caught hold of local readers, and many would find themselves stammering up to John's booth at Pat's declaring that they had solved the riddle of who Ol' Timer really was. This kind of impact with the readers is something that most writers only dream about, and while he achieved this, he also was dubbed town historian and has been ever since. While John's core interest resided in Guerneville, he certainly wasn't without knowledge of the surrounding river villages, such as Rio Nido, Guernewood Park and Monte Rio.

In the 1980s, Guerneville saw harsh economic times. With the official "pop" of the resort area's booming bubble, many businesses went underwater (some literally), and newspapers, including *The Paper*, folded under the pressure. John continued as bailiff at the courthouse in Santa Rosa, writing periodic articles here and there for county historical publications. When he retired in 1998, he was able to devote more of his free time to history, including serving on numerous historical boards such as the Sonoma County and Russian River Historical Societies. In 2011, John and I coauthored and released *Then & Now: Russian River*, a pictorial history of the Russian River communities. That same year, he conjured the idea of gathering his articles into one publication and approached me

about the project. Roughly a year after work began, we've presented this final product to you, the reader.

The story of Guerneville and her sister villages is multifaceted, and not one perspective can tell the whole story. Within the following pages, though, you'll find yourself on a journey through John's eyes. The stories you are about to read are the fruit of countless hours of research, transcription and John's passion for history. Beginning and ending with the "iron horse" of the rails, John takes you on a journey to the past, to a time when life was simpler, when Guerneville and her sisters were but mere settlements perched on the banks of a wilder river known then as Shabaikai.

<div align="right">Valerie Ann Munthe, Young Historian</div>

INTRODUCTION

These stories and anecdotes are the result of trying to capture local history. This all started over a half century ago as a curiosity, then a thirst and then a driving quest to find "the old-timer" (female and male) who witnessed, lived and/or preserved their and their family's recorded past events. I had to set a geographical boundary in order to make some sense of all the gathered information. So I declared anything east of Hacienda Bridge was New York, land north of Red Slide and Mount Jackson was Seattle and all territory south of Tyrone and Pocket Canyon was Los Angeles. Inside this boundary, embracing eighty-four square miles of tall redwoods and the Russian River, are about a dozen towns and villages, each with its own multitude of stories and characters. They were and still are fair game to be caught by my pen.

So, return now to those days of yesteryear...

Part I
BUILDING THE RIVER

BUILDING THE GUERNEVILLE BRANCH

The Northwesterner, *North West Pacific Railroad Historical Society*

The construction of the San Francisco and North Pacific Railroad (SF&NP) between Santa Rosa and Healdsburg occurred from October 1870 to July 1871. Between these two towns was Fulton Station. Some four years would pass before a railroad would be considered for construction from Fulton west to the lumber town of Guerneville situated on the Russian River.

The lumber industry slowly matured in Guerneville, from one mill in 1860 to six mills in the early 1870s. Initially it took one to two days to haul wood products by teamsters the more than sixteen miles from town to Santa Rosa. The prospect of an ever-increasing industry and the necessary speed to get the lumber to the Bay Area market called for the mill owners and Peter Donahue, president of the SF&NP, to have a conference. The subject of discussion was who would supply what to get a railroad to the redwoods and, most importantly, which farmers would allow the road to be laid on their land. Rights of way were obtained by grants from over twenty landowners in exchange for "considerations and sundry conditions" and, with one or two exceptions, for "one dollar." A few names of those landowners from 130 years ago are still with us: Fulton, Covey, McPeak, Ridenhour, Heald and Guerne.

Ground was first broken on August 18, 1875. A mass of picks, shovels, scrapers and wheelbarrows attacked the line laid out by the surveyors, and by mid-September, 150 men were moving earth along the right of way between Fulton and the Laguna de Santa Rosa, four miles to the west. The road was then graded one and a half miles, with some two hundred yards of fifty-six-pound rail promptly laid down by the track gang of 25 men under the command of Foreman Patrick Hyde. Five flat cars were running daily, hauling ballast over the SF&NP from the Russian River near Healdsburg. Meanwhile, James A. Kleiser, superintendent of construction, was hiring all the teamsters he could get to haul timbers for the 1,280-foot trestle and bridge to cross the Laguna. The project began with enthusiastic fury.

At this same time, surveyed sites for the Green Valley Creek Bridge and the Russian River Bridge (at Hacienda) farther west had been located by the survey crews under the charge of J.C. DesGranges, of Oakland. These crews had been having an easy time with their locations, as the greatest curvature was seven degrees and the grade was no greater than 0.5 percent over the whole branch. The maximum attained grade was 0.75 percent.

Construction of the branch line was occurring simultaneously all along the right of way. By November 1, the cut-and-fill grading was going on two miles west of Mark West Creek. To the east, the Mark West Creek Trestle was starting to take shape. The track, with sidetracks every two miles, was

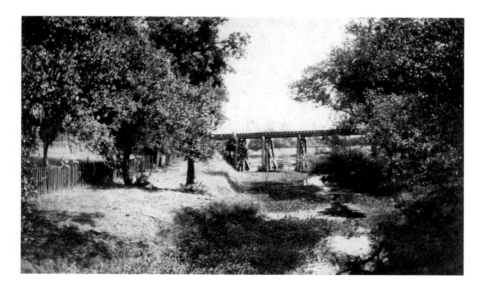

Trestle at the Laguna de Santa Rosa, facing northeast.

laid up to Mark West and ballasted to within a half mile of it. This enabled Mr. Baldwin of Petaluma to bring in his pile driver and commence pounding in the supports for the span. Once finished, stringers of Oregon pine were installed. In mid-December, the rails were over the Mark West Creek Trestle and two miles beyond; ballasting was up to the east end of the span.

The workforce, now composed of 150 Caucasians and 250 Chinese, had graded the roadbed almost to the river, with the biggest cut being seven hundred feet long and twenty-five feet deep on the north slope of Trenton Hill. The railroad reached the Russian River just beyond Forestville Station, eight miles from Fulton. From here, the road ran parallel to the river along its south bank.

December became January, and with that change, the increasing rain and storms began to slow the project. The winter always slowed and sometimes halted all transportation and commerce to Guerneville. Residents and travelers alike were always floundering in the mud roads of winter. One citizen wrote, "It is hoped another winter will not pass without finding the iron band to bind us to the world outside."

All bridges for the line were first formed and put together at Donahue (on the Petaluma River). They were then knocked down and transported to the construction sites, where they were reassembled. Bridging Green Valley Creek was underway the last of February 1876. The last trestle approach was 300 feet long; spanning the creek proper was a Howe Truss Bridge of 150 feet and connected on the west end to a trestle 200 feet in length. The whole assemblage was finished on site by the end of March.

Approximately one mile farther west was the east trestle of the bridge that was to cross the Russian River. This trestle was 1,300 feet long, terminating at the east pier of the bridge. The *Sonoma Democrat* printed, "The foundation of the pier is piling for 30 ft; 70,000 feet of lumber was used in its construction. The distance between this noble pier and the opposite bluff is bridged by a single span of Howe Truss, 181 ft, 4 in in length, across which the track is laid 51 ft above low water mark."

On Saturday, May 13, the first documented train, albeit a construction train, crossed over the bridge. The station established just west of the bridge was named Cosmo, known today as Hacienda. The grading continued on west to the Korbel Mill and the town of Guerneville.

When the railroad reached the river and ran parallel to it, the company had run into an ironic problem: redwood trees and stumps. The railroad was being built to the mills to haul out their redwood products; however, here were the very redwoods hindering the progress. After crossing the river, this

problem was magnified. Trees and stumps ten to twenty feet in diameter and located in the right of way were not uncommon. But still the laborers persevered, following the surveyors' grade stakes. The surveyors reached Guerneville on Saturday, May 20, 1876.

The tracks reached Korbel Mills on May 23. This was the first mill to be reached by the SF&NP and, as such, became the terminus until construction was completed to Guerneville. Before the railroad terminated at Korbel, the station was built along with a hotel, boardinghouse and cabins. Antone Korbel had a large residence in addition to the sawmill and shingle mill, plus there was a school. It was becoming quite the community.

The draw of the railroad with giant redwoods lining the right of way was the cause of several excursions to Korbel. The German Social Club of Santa Rosa had people attending a picnic riding "seven well-filled cars." More riders boarded along the road "until the train was loaded to its utmost

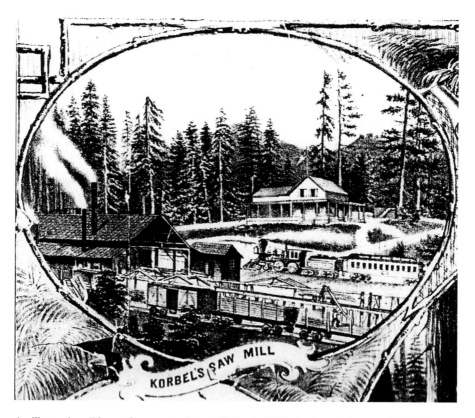

An illustration, "drawn from nature" by F. Keller in 1876, depicts the layout of Korbel's Saw Mill and the railway.

capacity. The platforms of the cars were crowded." The number of riders had swelled to about 1,200 by the time the train reached Korbel.

Everyday travelers wishing to go to Korbel or beyond rode on the construction train engine from Santa Rosa to Fulton and then climbed on a flat car and continued their ride to the end of line. From there, they walked down to the river and boarded Peckinpah's barge to float downriver three miles to Guerneville.

Starting on May 29, 1876, the SF&NP had its first train schedule published for the Guerneville Branch.

The right of way from Korbel to Guerneville was secured, and work was continued in earnest. The land west of Korbel was fifteen to twenty feet below grade, so cut and fill was the order for the next mile between Korbel and the bluff just east of today's Rio Nido. The bluff supplied most of this fill as workers carved, drilled and blasted out a roadbed at its flank.

By mid-August, the graders were camped on the edge of Guerneville. The right of way was cleared of stumps, and the roadbed was laid out on Polly Ann Street (today's Main Street). Heald & Guerne's Mill was to be the end of track at the west edge of town next to Fife Creek (today's Safeway parking lot).

The rails at Korbel, looking east. Note the large stumps among the plum trees to the right.

In September, the grading was complete through town, but numerous slides back up the track continued to hamper progress. With the roadbed completed, track laying was begun October 1 from Korbel.

The first storm of winter struck near the end of the month, demolishing the roadbed in several locations between Korbel and Guernville. The train could only come as far as Ridenhour's Ranch, a half mile short of Korbel. It was several weeks before the cars could be brought to the mill and lumber shipped out.

But winter rains continued to inflict damage with washouts and slides. Track laying had only progressed one-quarter mile beyond Korbel by January 1877. More storms drenched northern California. A Guerneville resident wrote, "Railroads have been damaged severely. A slide above Korbel's prevented the cars from reaching that place for several days, but the tracks are clear again. All the work recently completed below Elliot's Canyon (just west of Korbel) will need repeating as the cuts are filled up again. So, our railroad is again an affair of the future."

The roadbed was repaired, slides cleared and washouts filled. The track layers again employed their skills. Railroad president Donahue placed an advertisement in the local paper that fifty thousand ties, six inch by eight inch by eight feet, were needed along the river branch. The weather eased, and the tracks achieved their destination. Finally:

The Flag: The completion of the railroad is now an assured fact, and on Saturday, Feb. 24 the cars steamed into town for the first time. They were greeted with a salute from anvils, and blasts from the mill whistle, to which the engine responded. It was a general holiday in town, and nearly everyone was out to see that the long and anxiously looked for train was no illusion. The track is laid nearly to the creek, and Polly Ann Street is fast becoming a net-work of rails, side tracks, switches and the like.

BAGLEYS SHAPED HISTORY OF WEST COUNTY

Excerpt from Guerneville Early Days

The year 1865 was a pivotal one in John Bagley's life. Already married with three offspring, living in Healdsburg and a fairly successful mill owner,

he joined William Willets in a new operation. Willets owned a quarter section of land that had the densest stand of redwoods on record. A third party joined them: Thomas T. Heald, brother of Harmon, the town's namesake.

John and Tom disassembled Bagley's lumber mill and started hauling it down the trace, which would eventually become Westside Road, to Willets's claim at Big Bottom. They, along with a new fourth partner, George Guerne, literally carved a road in places where only a path had existed.

John and partners reassembled his mill on the east bank of Fife Creek, southeast of the intersection of what are today's Main and Mill Streets. John sawed the first board at this mill in 1865 and the mill's last cut in 1901. In 1866, he withdrew from the

John Washington Bagley, Guerneville's entrepreneurial father, constructed the first general store and post office and dubbed the small village "Guerneville."

partnership, but the others had him stay on as head sawyer until 1869.

In the meantime, he moved Ellen and their three children to a new home he built with his lumber at the corner of today's Mill and First Streets in Guerneville. In 1869, after considering how many people were residing and working in the area, John, along with the lumber business, erected the first store in Big Bottom. It included a meeting hall on the second floor. In 1870, he thought there were enough people present to warrant a petition to Washington, D.C., for a post office in "Guerneville." The office was approved, and John was made postmaster at twenty-six dollars per year.

John and Ellen helped to increase the population of the town with three more children: Frank John, Alice Clare and Carl Elmer, born between 1871 and 1877. All the Bagley children lived until adulthood.

The Bagley store was the de facto city hall. All tax collections were made there, elections were conducted there and the upper hall was used as a dance hall and, at times, a funeral parlor. Yes, J.W. Bagley had another trade: local sexton. He retrieved the dearly departed, made the coffin and transported some to the

Elizabeth Bagley, wife to John, was nearly as passionate about preserving Guerneville's history as her husband.

local cemetery—one that he plotted out formally in 1876. He retained his business as undertaker along with his role as a surveyor until his death.

His reputation as surveyor was well known and was supported in later decades by the courts as among the best in the area. As previously stated, he surveyed while conducting a multitude of enterprises during the 1870s. John's transit skills were honed during this decade. Sorely needed lines were run along timber claims for various contracts between timber owners and mill operators. County roads were first documented by Bagley's work. In 1872, mining claims were laid out during the "quicksilver rush" on the west slope of Mount Jackson.

As his reputation spread, his skills and expertise became more in demand. When the County Board of Supervisors created a new school district, the boundaries were marked by Bagley. The same occurred when the bridge site over the Russian River was selected by the county.

In the mid-1880s, local railroads were incorporated, done by Colonel Armstrong (of state park fame) and the other by George Guerne. John was hired by both to survey potential rights of way. The Armstrong and Big Bottom Railroad never got off paper, but the Guerneville and Russian River Railroad eventually laid rail on Bagley's survey. This road ran west of town to Hulbert Creek and then up the creek. The two-and-a-half-mile short line became, in part, a section (though small) of the Guerneville branch of the Northwestern Pacific Railroad.

On several occasions when Bagley was working in the field, he would rely on notes of previous surveyors. He would discover some notes were false; he would write in his own journals: "This corner is false as hell...as he was never at the corner nor at the section corners E, W, S, N of it," and "Between Sections 26 and 27 the following notes by the original Surveyor V. Walkenrider shows the fraud committed by him to leave the brush and take to the timber."

Among his many returning clients were the Korbel Brothers, Bohemian Club of San Francisco, Great Eastern Mining Company and Duncans Mill Land and Lumber Company. He worked continually through the 1890s into the twentieth century. His last survey was run on February 11, 1906, for Mrs. L.E. Ridenhour.

In J.W. Bagley's private life, he was a dedicated supporter of the Union. He joined the Working Man's Party, an anti-Chinese organization of the 1870s that advocated returning all Asians to their homelands. His attitude changed, as demonstrated by the fact that he hired Chinese people to work on county roads when he was road overseer in the Redwood Township from 1875 to 1877. Bagley was also a member of the Independent Order of Good Templars, a temperance group.

On February 18, 1906, Bagley was returning from Duncans' Mills, where he was called as undertaker. It was raining heavily that Sunday as he drove a buggy back to the stables in Guerneville. When entering the stables, the horses slipped on the wet planks and fell. The quick stop pitched Bagley forward over the horses, and he struck his face on the brick entrance. His face was crushed and his left side paralyzed. He lingered until February 22, when he died—on the birthday of his namesake.

THE GUERNEVILLE & RUSSIAN RIVER RAILWAY

The Northwesterner, *North West Pacific Railroad Historical Society*

This is a history of a really short line railroad in a rural setting—hence a short history. The San Francisco & North Pacific Railroad had some sixteen miles of track from Fulton west to Guerneville. The line was constructed in 1875–77 and was used primarily for hauling lumber from the main mills operating throughout the redwoods and along the Russian River.

Four years later, in January 1881, the Guerne & Murphy Lumber Company purchased a locomotive along with some cars. The North Pacific Coast Railroad's cash book records show that on January 21, 1881, "Old locomotive and three flat cars of San Rafael and San Quentin sold for $580.00 to Heald & Guerne." The locomotive was built in San Francisco by the Vulcan Iron Works in 1864, a 2-2-0 with nine- by ten-inch cylinders. This engine was previously owned by three railroads before Guerne &

Murphy built a track from its mill in Guerneville along the north bank of the Russian River a half mile west to its vast timber holdings at Hulbert Creek. Construction began in early spring of 1881, and by mid-May, the railroad had reached Hulbert Creek and the monstrous redwoods. The other end of the road connected with the SF&NP at Guerneville. Costs ran as high as $3,000 per mile.

As with earlier railroad building in the area, the construction was probably done by Chinese laborers with track-laying experience who worked under the supervision of SF&NP. The iron rail was purchased from the SF&NP. There were two bridges built, one over Fife Creek and the other over Livreau Creek just west of town. Farther along, trestlework was erected before the rails reached Hulbert Creek in today's Guernewood Park. At the end of May, a bridge was put across Hulbert Creek. The tracks were then directed up along the creek. The following year—1882—the line was extended just over one-quarter mile. At the end of 1881, its first logging season, the Polly Ann was taken down the SF&NP at Donahue for an overhaul and full repair. It was returned to its haunts in January 1882.

For the next five years, the track was slowly pushed farther and farther up the canyon. Polly Ann hauled huge redwood logs down the canyon and then upriver to Guerneville and the mill.

During these years, there was winter flooding and destruction. In March 1884, storms did considerable damage to the railroad. The area of "Cape Horn" (one-quarter mile west of Hacienda Bridge) was and still is a problem with landslides. These slides isolated Korbel Station and Guerneville from the rest of the world. The Polly Ann was pressed into passenger service, ferrying people to the two stations on a flat car. This public service continued into mid-April.

After much destruction by these past winters, Guerne & Murphy rerouted the railroad in the spring of 1886 to lessen losses. The rails were moved onto a declared county road.

The Sonoma County Board of Supervisors was informed that the public road in Hulbert Canyon was obstructed:

> *Said obstruction be* [sic] *placed there by the domineering autocrats of Guerneville, Messrs. Guerne & Murphy who have at said point appropriated for there* [sic] *own purposes nearly seven hundred feet of the public highway and with characteristic impudence, refuse to remove said obstruction. The public hiway* [was] *appropriated by the road fiends of Guerneville for private purposes.*

And what did the county do then? Another county road was constructed alongside the railroad. The "nearly seven hundred feet" is just over 1/8 mile in length.

During the summertime, the lumber company would haul campers and excursionists down to Hulbert Creek groves to "rusticate" in the area known as the "picnic grounds." This was part of Guerne & Murphy's holdings that extended about another quarter mile along the north bank of the river. In the mid-1800s, conventions with up to eight hundred people would camp under the redwood canopy. There were camp meetings that lasted up to two weeks with as many as two thousand people in attendance.

In March 1886, Guerne & Murphy and three other local businessmen formed a company to expand the access to more lumber resources. They incorporated themselves as the filed legal papers declared:

> *Know All Men by These Presents:*
>
> *That we the undersigned have this day associated ourselves together for the purpose of incorporating under the laws of the State of California a corporation to be known by the corporate name of "The Guerneville And Russian River Railway Company."*
>
> *And we hereby certify that the objects for which this corporation is formed is to build, equip and operate a Rail Road from the Town of Guerneville, in the County of Sonoma, State of California, to the mouth of Russian River where said River empties in the Pacific Ocean and also to build, equip and operate a branch line of Rail Road from a point on said main line about three miles from the said Town of Guerneville to a point about two miles distant on the opposite side of Russian River. And said corporation intends and it is its object to conduct the business of common carrier for hire of freight and passengers on its said Rail Roads.*
>
> *The estimated length of said Rail Road from said Town of Guerneville to said mouth of Russian River is fourteen miles and of said branch road two miles making in all sixteen miles of Rail Road.*
>
> *That the principal place of business of said corporation shall be in the said Town of Guerneville.*
>
> *That the time of existence shall be Fifty years from the date of its incorporation.*
>
> *That the number of its directors shall be Five; and the names of those who shall be directors and serve as such officers the first year and until the election and qualifications of their successors are:*

Rufus Murphy of Guerneville
George E. Guerne of Santa Rosa
John French of Guerneville
George Locke of Guerneville
John Q. Bradbury of Guerneville

 That the capital stock of said corporation shall be One Hundred Thousand ($100,000) Dollars divided into One Thousand shares of the par value of one hundred dollars each.

 That the amount of capital subscribed is Sixteen-thousand dollars and more than ten per cent of the capital stock subscribed has been paid to the Treasurer of said corporation.

 That the names of the subscribers and the amounts by them subscribed are as follows to wit:

Rufus Murphy—65 shares $6500
George E. Guerne—65 shares $6500
John French—10 shares $1000
George Locke—10 shares $1000
John Q. Bradbury—10 shares $1000

 That for the first year and until their successors are elected and qualified George E. Guerne shall be President and Rufus Murphy Secretary and Treasurer of said corporation.

In witness whereof we have here unto set out hands and seals this 6ᵗʰ day of March A.D. 1886.

George Guerne, age forty-eight and the town's namesake, was the last original owner of the mill erected in 1865. Rufus Murphy arrived in 1870 and, with brother-partner Wyman, had a profitable mill north of Guerneville. Rufus left this partnership and joined Guerne in 1880. John French was a successful logging contractor and mill owner. At this time, he had a contract with Guerne & Murphy. George Locke was a prosperous building contractor in the area and owned a large tract of timber. John Q. Bradbury is an unknown in the Russian River area.

To demonstrate their intent to build a railroad to the ocean, the Guerneville & Russian River Railway hired local surveyor John W. Bagley, a former mill partner with Guerne twenty years earlier. Later in the same month as the incorporation, Bagley started running chains with his crew along the existing railroad onto the picnic site and beyond, going down the right bank to Huffsetter's Bend (today's Northwood). Bagley's two-day survey was three miles long; this survey was eventually built up by SF&NP.

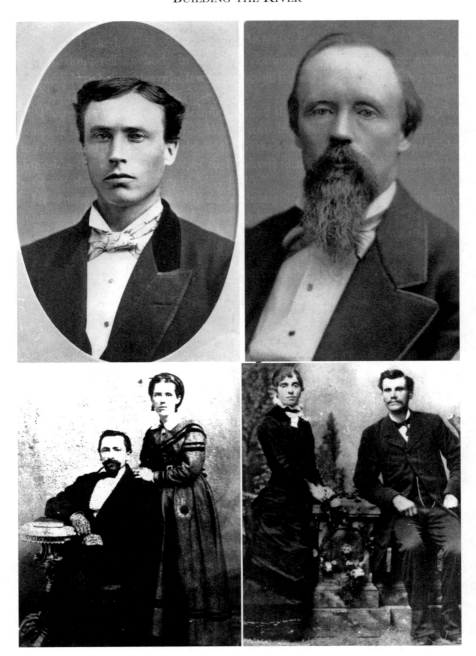

Top left: John Locke; *top right*: Rufus Murphy; *bottom left*: George and Elizabeth Guerne; *bottom right*: George French and wife, Etta (Folks), circa 1882.

In May, the Guerneville & Russian River Railway laid in the logging railroad extension in preparation for cutting down the picnic grove by going straight to the west into the picnic grounds, crossing Hulbert Creek below its 1882 crossing upstream. This branch ran 650 feet west of Hulbert Creek.

For the next three years, the original track was extended up the Hulbert Creek, crossing so often that the railway was nearly half on bridges and trestles. The road finally terminated 0.42 miles up Finley Gultch, 2.30 miles from the mill. The rail used into the gulch was twenty-five pounds per yard, similar to mine rail. A short branch line went up Hidden Valley about one-quarter mile; no further trackage was built by the company.

During 1888, the twenty-four-year-old Polly Ann was being dismantled; its tender stayed in a vacant lot near Guerne & Murphy's office. The tender suddenly ceased to exist after George Guerne blew it up with "Giant Powder" on New Year's Eve 1889. The biggest pieces were thrown 150 to 200 feet away. The remains were heaved 30 feet aside, leaving a crater 3 feet deep where the tender once resided. New Year's Day saw Guerne going all about town paying for the damages to walls, windows and roofs.

During the first part of June 1889, the SF&NP Railroad purchased the Guerneville & Russian River Railway with its holdings. (The lumber company was sold separately to the Sonoma Lumber Company.)

Thus, three years into its fifty-year declared existence, the Guerneville & Russian River Railway ceased running.

RIO NIDO CENTENNIAL

Yesterday & Yesteryear, *December 2010*

Note: The name Rionido/Rio Nido is now one hundred years old. This important year for the village almost went unobserved by the author. But its beginnings go back further than 1910.

The earliest pioneer who located in today's Rio Nido Canyons was William Fry, sometimes spelled Frey. This twenty-eight-year-old, listed as a laborer, was known to be in the area as early as 1860. By 1864, he was in possession of a quarter section (160 acres), which is now all of central Rio Nido, and all of its virgin redwood forest. No records or histories show if he built a home here or not.

The Korbels became owners of Fry's land prior to 1876 plus those acres to the north and east of it. They had a mill operating at the time to the east where their current wine cellars are today. The arrival of the railroad came in the spring of 1876 to Korbel Station and continued on. At Fry Creek (the entrance to Rio Nido), a culvert was constructed for the overlaying railroad bed. The railroad arrived at Guerneville in February 1877. Today's River Road goes over this original railroad landfill.

The railroad opened new logging opportunities for Korbel. Typical of the times, when timber was logged out in an area, the owners would move to a new location. The Korbels were no different. They had their mill erected in Rio Nido in 1881. With the last of the timber cut, they pulled out their mill in 1886. The ownership of the land didn't change until 1905.

In 1904, the Elks Club was seriously looking at the property for purchase as a vacation park and resident location similar to Odd Fellows Park just upstream of Korbels. However, the Elks national board of directors decided not to attain ownership after much review and discussion.

In 1905, the Russian River Land Company was formed and purchased the acreage from the Korbels. Roads and lots were surveyed. In 1906, Rio Nido Road was built over to Mercury Road, known today as Armstrong Woods Road. It was 1907 when the property was divided and lots were sold. Bungalows and cabins were thrown up among the young and short second-growth redwoods.

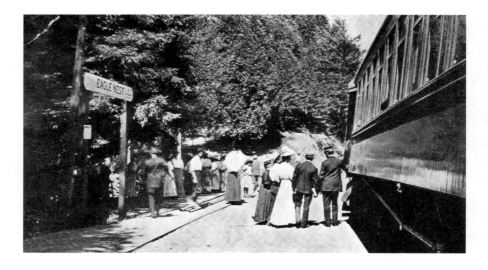

Postcard dated 1911 showing passengers arriving at Eagles Nest Station, also known as Rio Nido.

Froehlich's "Tent City" in 1925.

The first commercial buildings in Eagles Nest were all designed as rustic structures, like the cabins and bungalows, all in keeping with the rustic nature setting of the redwoods scattered about the area. These were unpainted raw board stores with railings and banisters similar to redwood limbs ringing the porches.

Enough people had made residence there that the U.S. Post Office Department established Eaglesnest Post Office on May 23, 1908, and appointed Gilbert P. Hall its first postmaster. Two years later, on May 23, 1910, the U.S. Post Office changed the name to "Rionido." This single name remained until June 1, 1947, when it was changed again to Rio Nido.

About 1915, William Smith purchased the property of central Rionido and founded Rionido Incorporated. Under his direction, money and labor, Rionido became a resort and not just a location for summer homes. In 1918, major construction of permanent year-round structures was underway. Since he came from England, Smith had the hotel and other summer concessions built in Tudor-style architecture.

At the same time, A.J. Froehlich established his "Tent City," the second-largest "resort" in Rio Nido.

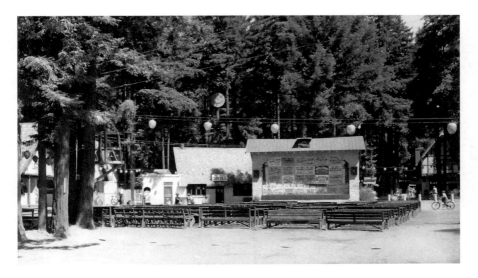

The winking moon is seen at center, 1942.

In the 1920s as you entered Rio Nido, the commercial buildings were to your left, starting with a grocery, a variety store and a souvenir gift shop in the first building, and then a shooting gallery. Then there was a footbridge over Fry Creek, followed by the dance hall, the Candy Store ice cream soda fountain, the Rio Nido Theatre, the Kennel hot dog stand and, last, the Rio Nido Grill with its beer, wine and mixed drinks. Across the road on the north end of this area was the imposing Rio Nido Hotel.

William Smith died in 1923, and his son, Guy Duncan Smith, took over the resort. Sometime during the '20s, the Smiths took on Dr. Ross Hamlin of Santa Rosa as a partner. In 1926 or 1928, Harry Harris bought out Guy Smith and joined in partnership with Dr. Hamlin.

It was probably Guy who created the phrase "Memories That Linger," as this famous phrase was on a 1925 brochure. That other icon, the winking moon looking down from the redwoods, was up by 1937 and probably earlier. It was approximately six feet in diameter with a face on light orange cloth. It had ten to twelve lights around the rim behind this, and at night, they were turned on. A light behind the left eye blinked, making it appear as though the moon was winking.

It was typical of the '20s and '30s that nearly every village and town along the river had a dance band all summer long. They were college bands from around the Bay Area. Reg Cole and his group were a fixture at

31

Guernewood Village Bowl, and Larry Rapose performed with his band at the Grove in Guerneville.

Rio Nido bands held sway at the dance hall. It was an open-air pavilion that spanned Fry Creek. Returning seasonal bands included Pete Horner, a professional musician in the late 1920s; Chuck Dutton for 1930 and '31; followed by Lee Searight through the mid-'30s. In 1938, the hall was roofed over by local contractor Jack Shatto.

Interspersed with the summer-long bands were the one-night stands of the big bands of the 1930s, '40s and '50s. The names are legend: Ozzie Nelson, Phil Harris, Harry James, Woody Herman—the list goes on and on. Other entertainment, if the vacationer didn't wish to dance, was sitting around the big evening bonfire just outside the dance or going to the local movie—"silents," of course. The Harris family pretty much ran this operation at the end of the '20s. Rose Harris (mother and spouse of Harry) sold tickets for ten cents each, while son Herb was the projectionist.

In 1940, Harry Harris bought out Dr. Hamlin and Guy Smith, thus becoming sole owner of Rio Nido's commercial center. Note that Rio Nido as two words was in use by the general populace as early as 1930. And later in 1947, the name of the post office switched from one word to the more common two-word.

In 1953, the Harrises sold to the Magliocco brothers, Emil and Sam, of San Francisco.

GUERNEVILLE BRIDGES THE GAP: THE STORY OF THE TOWN'S FIRST TRESTLE BRIDGE

Sonoma County Historical Society Journal, 1988

Descriptions of roads along the Russian River during the 1870s were not at all flattering. A perceptive writer stated:

> *Some cities and towns build their hopes of future success and greatness upon the fact that they are at the terminus of a railroad—as Healdsburg once did. Guerneville, however, cannot quite do that, but we can boast of being the terminus of all the wagon roads that come into the place; and even better than that, for they all terminate before they get here for about four months in the winter.*

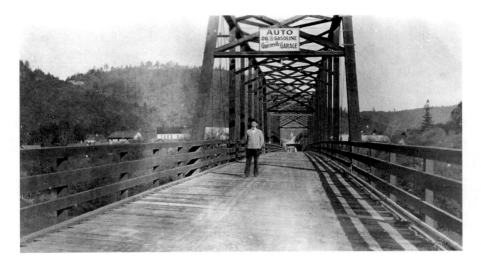

A northern view looking across Guerneville's first bridge.

An attempt was made to have a permanent bridge constructed across the Russian River from Pocket Road to Guerneville in 1875. Petitions, five in number, were circulated throughout western Sonoma County, consisting of Salt Point, Ocean,[1] Mendocino[2] and Redwood[3] Townships, as well as parts of Santa Rosa Township. There were over one thousand signatures, all in favor of the construction of the structure. The petitions were presented to the board of supervisors on May 3, 1875. The supervisors visited Guerneville "for the purpose of selecting a suitable site for a bridge across said river."

An engineer was appointed to draw plans for erecting a bridge and estimate a rough idea as to costs. The report stated it would have two 180-foot spans at a cost of $18,500.[4]

Two days after the board viewed the site, it reconvened at the county seat, and the matter was taken up for consideration. The board rejected it. The rejection was likely based on the prohibitive cost and the small population that such a bridge would serve. There was, of course, a low-elevation temporary bridge constructed across the Russian River each spring to consider.

Since the town had come into existence some twenty years earlier, the populace here and in the surrounding countryside had tried every means

1. Now known as Jenner.
2. Now known as Healdsburg.
3. Now known as Guerneville.
4. Equivalent to approximately $362,900 by today's currency.

at their disposal to have the board of supervisors in Santa Rosa construct a bridge. This, after the arrival of the railroad, was their greatest desire. After every storm, bridges, culverts and roads were badly damaged. A writer to the *Sonoma Democrat* said:

> *Not an ounce of freight, nor a single passenger can get west of Russian River at this point, as far north as Healdsburg, 18 miles and westwardly to the ocean, except by rail. Several thousand people out here are thus hemmed in for about three months every rainy season. The fact is Guerneville needs a bridge across the river so that people on the other side can come here for lumber, and so we may get out with teams to Santa Rosa. It is a burning shame.*

Back in 1875, a bridge would have been built except no one among the supervisors and engineers could agree where to place it. Now the population of Redwood, Ocean and Salt Point townships had increased four-fold. The people's choice in locating the bridge was at the fording from town to Torrance's[5] on the south bank. The banks had remained stable, as well as the riverbed. The danger of floating trees was about over as the timber upstream had nearly all been cut away.

Letters from the area to Santa Rosa newspapers in support of a bridge were about one a week (the papers were weekly) for a period of five or six months. There were none to the contrary. In July 1884, the Grand Hotel was the scene of a town meeting. A committee of twenty citizens was selected to present a petition to the supervisors. The names are familiar: Rufus Murphy, John Taggart, L.M. Ellison, Granville Thompson, M.D. Haskins, C.D. Yarborough, Henry Beaver, O. Shoemaker, A. Wehrspon, J.H. French, R.E. Lewis, S.H. Torrance, H. Haas, John Folks, L. Ridenhour, S.D. Ingram, Dr. J.A. Burns, J.H. Fowler, A. McFadyen, D. Hetzel, Dr. S. McGuire (secretary) and J.B. Armstrong (chairman). This final petition was drawn and presented to the supervisors on July 8. Duly impressed and finally recognizing the people at large were demanding construction, the board granted the people's wish.

The county had two proposed sites surveyed: one at the usual town fording and the second downstream where banks were higher and a new road would have to be constructed. This second site would place the bridge at right angles to river flow and enter the center of town. It would have been selected by the supervisors in April 1885 only if the right of way would be given to the county by Guerne & Murphy, plus a few other minor contingencies. An agreement

5. Roughly two hundred yards east of the Pedestrian Bridge, now located on Riverlands Drive.

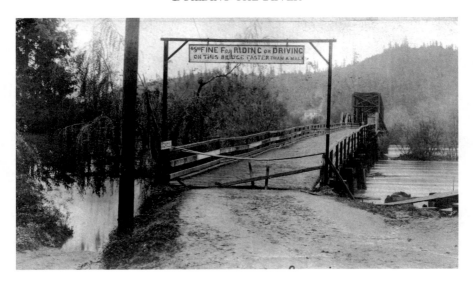

Gazing south down Guerneville's first bridge during high water, many years before the previous photo.

was not reached, so the first site was chosen. The California Bridge Company of Oakland received the contract on its bid of $11,970. The trestlework ran $3.20 per lineal foot. The two main spans were Iron Pratt combination truss; 150 feet of trestlework for bridge approaches would be built. The work was to be completed within one hundred days from May 8, the day the county and company signed the contract. This made the deadline August 17, 1885.

The first two weeks were spent preparing the grounds and grade and setting up the eighty-foot pile driver. On May 25, work on the structure started by driving piles for the three sixty-foot-high piers. Each pier consisted of twenty-six pilings, sixteen inches of clean heart redwood eighty feet long and driven twenty feet down. The piers were completed on June 7—thirty days gone.

With a donkey engine and a workforce of eighteen men, construction proceeded rapidly. The main spans with their iron and wood chords fairly flew together. Lumber was hauled from John French's mill as fast as possible. Stringers were slammed into place; pins anchored lateral and portal rods. Iron sheet plated the upstream points of the piers. All joints and connections were painted and soaked with paraffin paint. The builders predicted that the bridge would be finished by August 1, sixteen days ahead of schedule. But they were wrong. They finished on July 31, seventeen days before the deadline.

Now freight, passengers and travelers of the northwest section of the county were not dependent on the railroad during winter months to move in free

commerce. No longer was there danger of losing life, stock or property while crossing the ford to Pocket Canyon and the south bank.

In September, signs were erected over each end of the bridge: "Fine $5 for riding or driving faster than a walk." This was the final touch.

Concrete Highway

The Paper, *August 28–September 3, 1981*

I was sitting at the counter in Pat's nursing a cup of java. A few customers were nibbling late lunches. It was warm, and the shoo-fly fan in the front door was stirring small zephyrs about the café.

"Well, well, well. Look who decided to show up. How ya doin', Youngster?" a voice boomed into the café.

"Hello, Ol' Timer," I responded. He still looked the same—white hair thinning on top, weathered craggy face with a four-day stubble of beard. He was missing his mackinaw and old navy knit cap—it *was* summer.

He shuffled in and asked, "How's summer treatin' ya?" and plunked down alongside me.

"Pretty good," I responded. "I've been poking around bookstores and canyons still looking for more history about our river area."

"Did ja fine anything?"

"Well, that's hard to say. What is common today becomes sometimes important tomorrow. Like the new center turn lane in Main Street, it may be a step to having a signal at the intersection."

"Yeah," said Ole Timer. "Remember when they put up that stop sign there by the drugstore? Been 'bout twenty years now."

He started squinting, looking into the past. I could almost hear his brain cells clicking, digging deeper into the years.

"I 'member when the first highway was finished comin' inta town. It was a concrete thing through Pocket Canyon. Ya can see by the asphalt cracks where the ol' road is."

"When was this?" I asked, prodding him for more facts.

"'Bout '28 or '29." He chuckled to himself. "I seems to remember that I was datin' a girl then—she was one of about six that was runnin' fer queen or some such thing. The people here had a big celebration 'cuz of the new road."

"I never heard about it," I said, grabbing a napkin to make notes.

"Hol' on there, Youngster, I got a ol' newspaper about it, saved it 'cuz it got a picture of a ol' girlfriend an' others. I'll get it fer ya—be back in a minnit."

Donna brought two cups of coffee and wondered how long we were going to spend this time on dusty history.

Ol' Timer returned with a yellowed *Guerneville Times*, dated August 6, 1927. Across the top was a blaze that read "Highway Celebration." Underneath was a photo of a bevy of beauties in bathing suits.

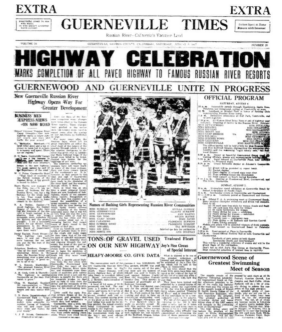

A snippet of news from the *Guerneville Times*, dated August 6, 1927.

A smile creeped across the old geezer's face as he studied the photo.

"Some fine lookin' wimmen," he said to himself.

"Where did the concrete come from for the road?" I interrupted his dreams.

"Oh. Well ya know where the Odd Fellows Bridge is—well, the ol' sand and gravel plant that was just downstream from there—ya can see the busted-up foundations an' piers there." (I checked later, and sure enough, they are still there.)

He continued, "The new road started at the upper end of the canyon and ended at the bridge here in town. It was about eighteen feet wide with a lotta sharp turns. Iffen ya go that way, notice how they paved the inside of the turns to kinda smooth 'em out."

While Ole Grizzle-face took a sip of coffee to water his tonsils, I scanned the paper and learned that the five-mile section of road between Forestville and Guerneville cost $126,322 and was built by the Heafy-Moore Company of Oakland. All the pavement concrete came from the mixing plant at the river.

I queried, looking at the photo, "Which of these girls was yours?"

The white head turned slightly toward me, and he looked out of the corner of his eye.

"Youngster, some a these girls is still with us an' my dad said don't never kiss an' tell, so's what I'm sayin' is we enjoyed each other an' leave it at that."

Ol' Timer sipped his coffee. I, mildly rebuked, watched a warm, stubbled face stare off thinking of those long-passed days. He abruptly came to the present, saying, "Well, Youngster, gotta go. Hope I did ya some good."

"You did," I answered. "See you in the *Paper*."

BUILDINGS IN ARMSTRONG PARK

The Paper, *July 2–July 26, 1979*

Armstrong Park: a place of solitude in the jumble of canyons and ridges, a quiet glen on a noisy weekend. It is also the site of many marriages. The Armstrong open-air theater has probably witnessed more marriages than the churches in Guerneville. This spot of beauty was created about fifty years ago.

It was at the start of the Depression when Bill Kenyon, local electrician; Henry Brown of the chamber of commerce; and "Cap Trine," a local boy in the U.S. Forest Service, wanted a theater up at the Grove. It was a county park at the time. The three men convinced some big shots to come up and look, but they couldn't see it.

So Cap cleaned up the brush, leaves and limbs. Then other bureaucrats came up, and one stood where the stage is now. He spoke to the rest at the back, standing with Bob Coon, park superintendent. They bought it.

According to Cap, the actual building of the theater and the old administration building at the park entrance didn't begin until funds from the federal agency WPA (Works Progress Administration) and the chamber of commerce came. The construction took place from 1934 to 1936.

The foreman was Cap, and he had a WPA crew working at Guernewood Park cutting trees from the flats, which Cap blazed. All the logs for the two projects came from there.

It was through Bob Coon that the U.S. Forest Service under Cap got a small mill. It was put up near Parson Jones Tree. Cap was appointed superintendent of the projects (not the park). The first project was the

administration building. The plans came from Sacramento. They used the mills to cut off two sides of the logs so they would fit snugly.

At the same time the forest theater was being built, the logs that were too large for use on the administration building were used as seats. At the stage, the logs were five to six feet long and placed on end to hold up the stage front. The building in the hillside to the left was the power transformer house for the stage; the hut on the right was a dressing room. The lumber for the stage was cut at the small mill.

The power line was trenched all the way to the theater. The cable was one and a quarter inches in diameter. The trench was filled with mine rock and four- by four-inch markers to show where the cable lay. The mine rock was also on the top so if it was dug up you would see it and not dig up the cable. The rock also helped in drainage.

When the theater was dedicated, the park and U.S. Forest Service people asked the county to use their water truck, and they said no. So Cap and his crew foreman took a two-inch pipe, drilled holes in it and attached it to a T that was connected to a fifty-gallon drum on the rear of a truck. With a couple of men filling the drum, they sprinkled the road in time for the grand opening.

The theater was formally dedicated—literally with a fanfare of trumpets—on September 27, 1936, at 2:00 p.m.

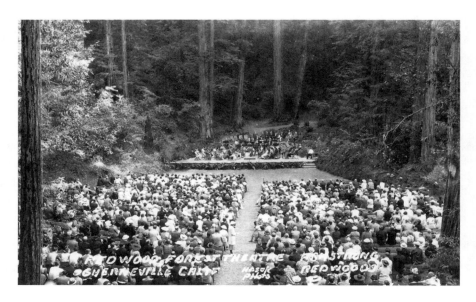

Armstrong's open-air theater during a summer performance of the Redwood Orchestra, circa 1936.

Relics of the Railroads

The Paper, *March 4–March 10, 1983*

It was a rainy Saturday morning in Guerneville. Rich Hines, perspiring in short sleeves, was giving solace to wet bodies seeking warmth in his Pat's Café.

The waitresses, Sam and Karen, yelled orders at Rich; Rich yelled the orders right back. I waited before placing my order of "wheat on rye, hold the mayo." I was slurping my second cup of coffee when a scratchy, high-pitched voice cut through the noise.

"Howdy, Youngster."

It was Ol' Timer, dressed in his usual mackinaw and knit watch cap with white hair squirting out from under it.

"Hello, Ol' Timer," I said as he plunked his barrel shape alongside me at the counter.

"Whatcha been doin'?" he asked.

"Trying to finish up my manuscript on the River's history. I'm not delving into the railroad, just giving it passing notice. Fred Stindt has written two good books about the Guerneville branch of the Northwestern Pacific."

"Those sure wuz fun times," said my bewhiskered friend. "Ya know, there's still some stuff left from those days."

"What do you mean?" I asked. "I know there are a few dilapidated passenger cars down at Duncans Mills."

"I wuz thinkin' of other things b'sides them cars. Like the railroad stations aroun' here."

"Railroad stations? You said that plural, right?" I asked.

"Yep," he said smugly.

"Ok, you old codger. What are you going to tell me?"

"Well, Youngster, there are several buildin's 'round here thet are still in good shape. I know ya musta seen the depot at Korbel's."

"Oh, yes, I had forgotten about it," I said, chagrined.

"They made thet one inta a 'visiter' center er something like thet. The next one, down the line," he continued, "is the boarded-up coffee shop at Rio Nido. It's a mess right now. Then there are some warehouses down at Bohemian Grove."

"How big are they?"

"Oh, I don' rightly know," my friend answered. "Kind a tall—barn high an' 'bout stable wide. Can't say how long they is. They ain't painted, just old

rough-cut redwood. Then there's one building thet was a station thet's still bein' used—the Cazadero store."

"Golly whompers, I didn't know that," I responded.

"Yep. The next time ya get up thet way, take a look. Ya kin see how it was a station, sittin' up kind a high-like with a platform out front."

"Down at Duncans Mills," I said, "they have done a great job of refurbishing the old depot. And the laundromat down there is a good reproduction, but I don't think there was ever a railroad building that big along the river."

"Yeah, but there are sev'ral other buildin's there thet was part of the railroad."

"Really?" I asked.

"Yep, iffen ya look 'cross th' highway from th' old depot you'll see a kinda garage-shed type thing. They was used fer storage 'n' the like. And ya know th' house they's kinda behin it?"

"Yes," I answered. "That's Rose Pedroia's home."

"Right," said Ol' Timer. "It used ta be a railroad house. An' then there's the corrugated iron shed out in DeCarly's field there near th' storage shed. It used ta be a pump house fer water."

"I didn't realize," said this writer, "there were so many structures left after the Northwestern Pacific pulled up the track in 1936."

"Well, Youngster, ya cain't be expected ta know ev'rythin'. Give ya a example—where's the Northwood depot?"

That son of a gun just sat there and chortled at my blank expression. If I wasn't locked into position, my jaw would have bounced off the counter.

"The Northwood depot?"

"Yep. It's only a couple a blocks from here. It's called the Guerneville Station[6]—a clothing store—right nex' ta Fife Creek."

"How do you know?" I asked skeptically.

"See, the train left in 19 an' 35. I left nex' spring ta log up Mendocino, an' I was gone when it was moved. Old George Sproul—'member him? He was constable here anyway, he had his realty office there an' he tol' me. Iffen ya go by down there take a gander at it an' you'll see."

He went on. "There's one other thing they's left from th' railroad—ya wrote 'bout it a short while back—a bridge. Ya don't know it at th' time, but Hacienda Bridge was th' one."

"Do you mean," I asked, "the bridge that is standing today?"

"Yep."

6. Known today as Flavors Unlimited.

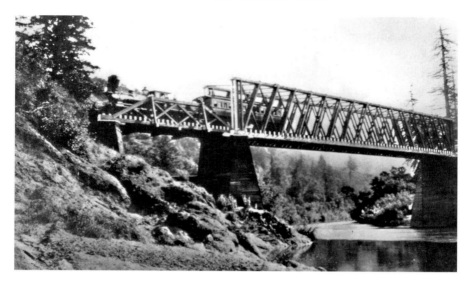

A train chugs across the river crossing at Hacienda in this circa 1877 photo.

"But it's too wide for a railroad bridge."

"Well, I know it looks kinda modern-like, but them engineers widened it. Thet's why it's got two dates on it, 1917 and 1947. An' iffen ya don' b'lieve me, ask any old resident 'round here—they'll tell ya," said my mentor in mock indignation.

Well, I wasn't about to do that and spoil a good friendship. Besides, my favorite old geezer has been right ninety-nine times out of one hundred.

"If I did ask, it would be to find out the history of it," I said. "You know that."

"True, Youngster, true. Well, I gotta be goin'. Ya got enough stuff now ta go scurryin' 'round an' get a article out fer The Paper."

"Ok, Ol' Timer. Take care and keep your powder dry."

He shuffled out into the rain. The noise of the café boomed at me again.

BRIDGES OF MONTE RIO

Yesterday & Yesteryear, *August 2010*

Note: The Press Democrat *of June 18, 2010, reported a truck sideswiping a truss on the Monte Rio Bridge. It came to mind that Sonoma County is seriously considering replacing the 1934 structure, hence the following history about the first permanent bridge.*

There was a great desire to have a permanent river crossing at Monte Rio, as it was three and three-quarter miles downstream to the railroad bridge at Duncans Mills and five miles upstream to Guerneville with no crossing save the railroad bridge at Northwood. For several years, a footbridge was constructed at the fording of the Russian River just upstream of Dutch Bill Creek in Monte Rio. These early first summer bridges were built strictly for foot traffic and were removed at the end of each tourist season. A semipermanent bridge with pilings was built in 1909 at the same location. Just the hand railings were removed for winter. Before the coming summer season, repairs were made to the pilings and wooden roadway if damage had been caused by the previous winter's storms. The hand railings were replaced, and all was made ready for the coming season. Though there were many summer bridges built at Monte Rio, it wasn't until 1911 that there was

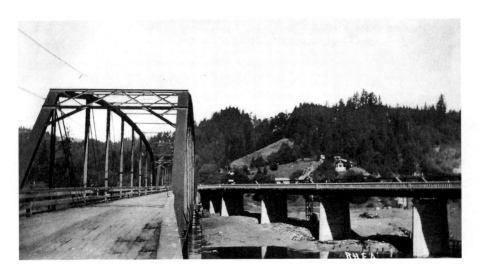

A photographic comparison during the construction of the newer Monte Rio Bridge in 1936. The current bridge, to the right, still stands today.

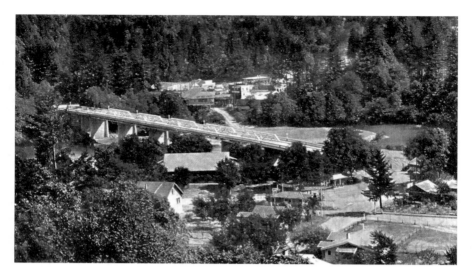

Monte Rio's new (and current) bridge, after construction, taken in 1940.

a movement by the county to build a permanent traffic bridge. In early June 1912, the board of supervisors viewed a prospective site. It was from the north bank where today's Rio Theatre is situated.

On August 6, plans for a bridge were submitted to the supervisors by W.L. Proctor of Proctor & Cleghorn, builders of many Sonoma County bridges. Bids for construction were opened by the county on September 5, and the successful bidder was Mervey-Elwell. Proctor was appointed project engineer by the supervisors on December 12. Copies of the contracts with specifications were submitted to the county on May 5, 1913. After perusal, the plans were modified to everyone's satisfaction and accepted by Proctor on July 10. The right of way at the north end of the proposed bridge was secured by Sonoma County from Mary and Hugh Breen with a deed dated April 15, 1913.

The property at the south end was likely owned by Charles Meadows, owner of the beach on the south side. The Russian River Improvement Club at Monte Rio gave a grand masquerade ball on May 3 to raise funds to help pay for the approaches to the new bridge. Construction commenced about May 20. The contract called for its completion by July 1, a period of forty-two days.

This new truss bridge was 871 feet long with three equal-length spans, each span 180 feet long and made with riveted box beams. The suspension girders and tension rods were pin connected (versus rigid connected).

The main spans rested on four piers of concrete and steel bar. The floor (roadway) was made of 3-inch by twelve-inch by twenty-foot redwood, laid diagonally. It appears that there were delays in the completion. The board of supervisors made its inspection on October 10 and accepted it, some three and a half months later. The cost of building the crossing was $24,837. This bridge would remain until 1934, when it was replaced by the current bridge.

TYRONE

Yesterday & Yesteryear, *July 2008*

The settlement of Tyrone had its beginnings in the mid-1870s on the west bank of Dutch Bill Creek, two miles upstream from the Russian River. The first structures were the lumber mill, built in April 1876, and the neighboring workers' crude shanties. The mill was the largest in Sonoma County. In 1877, the narrow-gauge North Pacific Coast Railroad descended Dutch Bill Creek to the Russian River, giving the mill hands and others easy access in and out of the canyon as well as ease in transporting lumber and machinery alike.

The superintendent of Tyrone Mill, owned by the Russian River Land and Lumber Company, was Dan F. Harback. The next year, 1878, Harback went on to superintend the company's Moscow Mill downriver. The Tyrone Mill foreman was Frank Plummer, who had run Murphy's Mill in Guerneville two years prior. Charles Roix, formerly with Duncans & Company, was foreman of Tyrone logging. The surrounding timber would give the mill six to eight years' worth of felling. The logs were hauled to the mill on an iron tramway. Charles Roix, besides working in the woods, ran a neighboring hotel.

To give a better picture and add some color to this area, the following is quoted from the May 19, 1877 *Sonoma Democrat*:

> *The Tyrone Mill…is running to the extent of its capacity. The whizzing of the saws, the clang of machinery, and the accuracy and precision, which thirty or forty men attend to their respective branches of business, is indicative of a perfect hive of industry and a system of regularity. The woods nearby are full of men felling timber, the report which sounds like the booming of cannon; the stentorian sounds of "whoa, haw, buck," with teams of oxen,*

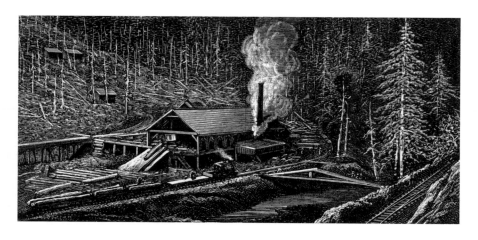

An etching of the Tyrone mill from *Frank Leslie's Illustrated Newspaper*, November 28, 1878.

*keep the mill supplied with piles of logs for its rapid execution. There are
100 persons employed in connection with the mill, mostly single men. There
are, however, some families and a few marriageable ladies in the vicinity…
So, let us conclude that the Tyrone is a "big think on wheels"; that these
hills she is destined to make her mark, and we can only express the wish
that her proprietors may prosper, that her large corps of workmen grow rich
and the pretty girls get married.*

In 1878, H.C. Smith was mill superintendent, and under his direction,
the mill's daily capacity was at thirty to forty thousand board feet in spite
of accidents. In June, a sixty-two-inch circular saw "burst." Pieces flew all
over the building, but fortunately, no one was injured. Replacement cost
was $300, and they lost three more saws before half the cutting season
had passed. If those weren't enough to keep you alert, millhand Michael
Nelan was crushed by a log rolling over him. He was rushed by train to San
Francisco but died before reaching San Rafael.

Tyrone also had its own post office established on July 18, 1877, as a
fourth-class office. Hiram C. Smith, superintendent of the mill, was made
postmaster. Four years later, the office was discontinued on June 30, 1881, but
then reestablished on November 28, 1882. Apparently the U.S. Post Office
couldn't make up its bureaucratic mind and discontinued it on October 15,
1883, never to open again. After this, if a citizen desired his mail, he had
to go to Occidental, Duncans Mills or Guerneville. Some nineteen years

would pass without a local office until Monte Rio's second-class office was established on May 26, 1902.

MESA GRANDE TO VILLA GRANDE

Yesterday & Yesteryear, *March 2011*

The early possessor of today's Villa Grande was the Russian River Land and Lumber Company. After much logging, it was sold to the North Pacific Coast Railroad Company. After all logging had been exhausted, this company formed a subsidiary, the North Shore Land Company, to develop its properties. By 1897, at the start of development, it gave the name of Mesa Grande to the area. It had a lumberyard located here for potential lot owners to build vacation homes.

Obviously, permanent residents were here before 1907. A fourth-class post office was established as "Grandville" on June 25, 1907, and was located in the Lunger General Store. Mary E. Lunger was the first postmaster and was still at that position in 1918. This post office gives more credence to the idea of an established populace well before 1907. More evidence of a prior-to-1907 population was the creation by the county of the Grandeville voters' precinct in 1908.

Here is a partial list of these "pioneers" of '07 and earlier, with known ages and occupations:

- George Batchelder, contractor
- Alonzo Gaylord Compton, printer
- Frank Hofmeyer, fifty-one, carpenter
- Max Kreutzberger, picture director
- Henry Elmer Lunger, forty-five, merchant
- Mary E. Lunger, postmaster
- Sue Paterson, housewife
- William Paterson, fifty-nine, contractor
- Fred Reck, fifty-one, cabinetmaker
- Benjamin Sheridan, 40, painter
- Theresa Sheridan
- Irving Menzo Wagner, carpenter

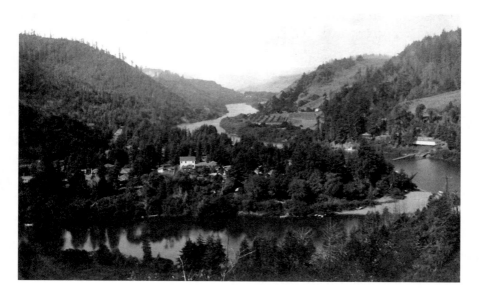

A hilltop westward view looking down on Mesa Grande (aka Villa Grande), circa 1915.

Between 1908 and 1910, others who made Villa Grande a permanent home were:

- Eugene Horgan, forty-nine, laborer
- Peter E. Johnson, thirty-eight, carpenter
- Charles Blanchard Tidball, forty-six, contractor
- Louise Tidball
- Benjamin Tucker, thirty-eight, carpenter
- Ella Roberts Tucker, housewife
- John Warner Varney, seventy-four

Ten out of the nineteen people listed above were working in some form of construction.

The North Shore Land Company had subdivided its real estate of Mesa Grande into 151 lots, forty by eighty feet. Riverfront lots were sold at seventy-five dollars and the remainder fifty dollars. By 1909, 111 lots out of the 151 were sold. In 1912, the company advertised, "At Mesa Grande, a lumber yard will furnish what material you may need for building purposes, also good contractors and carpenters, and everything that is necessary to further your interests in the construction of a summer home."

Another brochure stated:

> *A rustic cottage can be built of rough lumber, a good floor and liberal allowance of rustic porch, with a roof of shingles or ready made roofing and the necessary doors and windows. This will cost very little and can be built by most any man or youth. Beautify same in your leisure by shingling the outside walls and lining the inside with inexpensive burlap. Plant a few hop roots among the ferns around it, and you have a beautiful comfortable cottage at a very small expense, the value of which will increase yearly.*

A telephone was established by 1918 in Lunger's Grandville Grocery Store, the only phone in the village. The second phone number found (listed in 1927) was to Lew Kingsley: call 17–R. There were probably others before Kingsley.

On March 21, 1921, the name was reversed to Villa Grande by the postal service. At the time of this name change, Cecil Raymond was postmaster.

In February 1915, Herman von Blossfeldt started building the Mesa Grande Hotel. Nick Schneider just happened to be available, so he helped Blossfeldt. Grace Schneider must have been a little put out by Nick working— it was their honeymoon. Herman advertised in a 1926 vacation guide, "The hotel is modern, equipped with electric lights, hot and cold water in each room." The hotel also had tent platforms that had electricity installed. The rates were $3.50 and up per day or $20.00 per week.

Initially, there were two stores in Grandville. One store was across the street from the railroad station at the west entrance to Villa Grande. It is now a private residence. The second is the store we know today in the middle of the village. Caroline Kingsley and her brother Joe bought and ran this second store; however, Joe died two years after the purchase. Caroline then sold the store to Lewis Kingsley.

Attempts to discover who the people were that formed the Villa Grande Volunteer Fire Department have been for naught. The red shed (now vacant) used to house a hose cart and a chemical cart for firefighting. Both are now stored at Duncans Mills.

The first general store in Grandville (aka Villa Grande), taken in 1908.

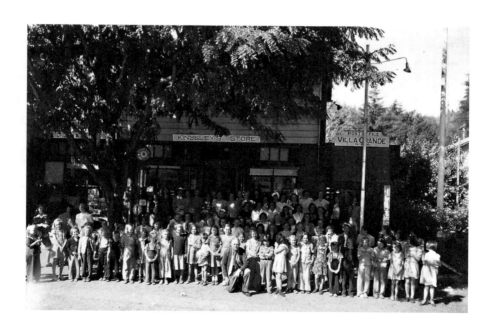

Children gathered outside Kingsley's store in Villa Grande in the 1940s. Mr. Kingsley is crouching in the front, center.

THE RUSSIAN RIVER SPORTSMEN'S CLUB

Yesterday & Yesteryear, *October 2008*

On the north bank of Russian River and on the east side of the Duncans Mills bridge sits the clubhouse of this organization. It was built twelve years after the formation of the club in 1936 and still stands after many floods, reaching this, its sixtieth anniversary.

The object of the club was and still is "the conservation and propagation of fish and game and to promote cooperation between the land owners, ranchmen and sportsmen." Another principal aim was to rescue fish that were stranded in the creeks and pools adjoining the river during late summer.

President for the first three years was Captain E.E. Lane, followed by Roy Klinker and Bill Makaroff, MD. During the war years, they were followed by K.H. Koehne, Jack Shatto, Bob Mann, Joseph "Red" Kerr and Joe Vatto.

In 1947, Angelo Boles pushed forward the idea that a clubhouse was a necessity. During the latter part of the year, it was decided to go with his idea. At the first of the year in 1948, a piece of property consisting of approximately six acres was purchased. On January 9, 1948, ground was broken, and seven weeks later, the clubhouse was practically completed. All was done by volunteer labor under the supervision of the architect, Harold Carlson.

Local contractors and heavy equipment operators came to the site with the tools of their trade. Tom King Sr. and Arthur Siri, general contractors, did the major excavation work to start the project. They also volunteered the use of their crane, operated by Henry Pacheco, to place the heavy floor joists and beams and, after the wall framing was completed, lifted the four massive roof trusses into position. Local homebuilder George Guerne showed up with some of his crew on days off to donate their talents. Other members who could swing a hammer or lend a hand were local businessmen, including Hilmar Grundberg, garage and auto repair; George Casini, sheep rancher; Angelo Boles, resort owner; Jesse Robertson, justice of the peace and auto shop; Jack Hetzel, resort owner; Lloyd Herling, bartender; Pete Dagnello; Frank Monticelli; Rudy Lagemann; Max Herling, restaurant owner; Shorty Parkins; and many others.

Though the name is Sportsmen's Club, women were just as active in the club as men. From out of the general membership stepped Florence Crawford, Margaret O'Brien, Grace Reinshagen and Gladys Pacheco, who

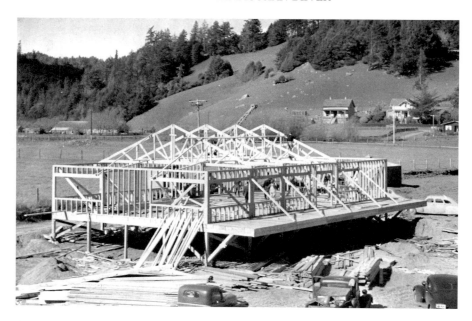

Construction of the Sportsmen's Clubhouse, 1948.

The clubhouse, to the left, completed.

were voted to the board of directors. Florence was on the board since the club's inception, serving at one time four years as secretary-treasurer. Gladys went on to become president from 1951 to 1953.

Because a new clubhouse demonstrated to the public that the Sportsmen were definitely going to be a permanent fixture in the county, membership in the club jumped from two hundred to six hundred in three months. The main funding of the club came from membership, potluck and annual dinners and, just as important, the annual steelhead fishing derby. Today, the Sportsmen's Club is supported by eighty members.

THE FERRY AT WILLOW CREEK

The Paper, *November 19–25, 1982*

"Howdy, Youngster." The graveled voice of Ol' Timer rattled to me down the counter at Pat's Café.

"Hello, Ol' Timer."

"Whatsa matter with ya? Ya look kinda stumped 'bout sumthin'."

"Yes, I am, I can't think of a "Stumptown Story" for *The Paper*. I've just run dry of ideas."

"I know what you mean," said Ol' Timer. "Kinda like what ta get a relative fer Christmas. Up th' river without a paddle."

"Speaking of the river, can you think of any tales about it? You know, maybe a flood or drought or a dam giving way."

"Humph," he said. "Well, lemme see. We talked 'bout th' tourists' boats at Monte Rio an' Gaye LeBaron writ 'bout th' *Enterprise*."

The codger rubbed his white stubbled chin in deep thought.

"I hear-tell of ferry boats on the river, up at Healdsburg las' cent'ry, an' there was one up at Gualala an' one down at Willow Creek. Natcherly, these was all afore th' bridges was put in."

"Well, I keep my stories confined to the river area. I had heard of the ferry down at Bridgehaven. I guess that is the same one as Willow Creek?"

"Yep. At times it was called the Markham ferry."

"What can you tell me about it?" I asked.

"Yer best bet wud be ta get a holt of Marie Graham down at Jenner, or Tom King Sr., or better Jane DeCarly."

"Thanks, Ol' Timer. I'll get back to you after a couple of phone calls."

I contacted all the people Ol' Timer mentioned, gathered the facts and returned to Pat's and my friend.

"Well, Youngster, what didja find out?" he greeted.

"I put it together," I said. "And it looks like this."

I dumped my notes on the counter. Millie called out from the kitchen, "As if the customers don't make a big enough mess, you two have to make a bigger one!"

"I've been telling them that for years," piped up Muriel.

"Jis ignore 'em, Youngster," he said as he looked over my story. He read:

There was a ferry crossing at Willow Creek long before the turn of the century. The only operator remembered by anyone now was Alex Cuthill, who started in 1918. Cuthill lived at the junction of Willow Creek and the river with his wife, name unknown, and son, George. He was a stooped-over fellow who worked by himself. He worked rain or shine every day with no vacation except when the river flooded. It was only then the ferry was shut down.

The ferry was about fifteen feet wide and long enough to carry three autos. On each end were aprons that dropped down for the cars to load and unload. There was a walk on one side of the boat, and the motor housing was on the opposite. It was painted white.

The ferry ran along a cable with pulleys while the motor-powered cable drums pulled on a second cable. This second cable went in one end of the motor house, around one winch and then over to another winch and out the other end of the house. For the return trip, the winches were just reversed. The motor was a four-cylinder thing like a Model T that chuck-chucked its way back and forth.

It took the ferry, with Alex at the controls, roughly ten minutes to cross the river. Time also depended on the tide. If it was running out, the ferry was pulled downstream hard against the guiding cable. The effect was like pulling uphill, because the power of the river joined the power of the tide. With the tide coming in, flood tide, the crossing was easier.

Back in those days of 1918 to about 1922, most of the vehicles were horse and wagon. Even later, there were not that many cars. During the summer, there was little increase in tourist traffic.

But whatever the reason, whatever the season, Alex Cuthill would "chuck-chuck" his way to and fro. It was cold when the wind blew (still is),

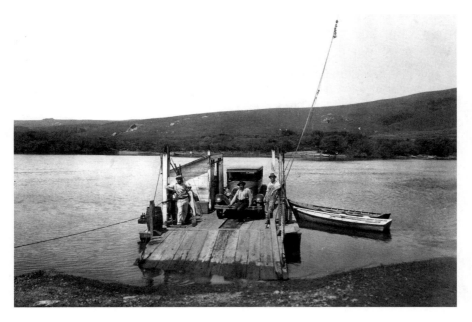

The vehicle ferry at Willow Creek. This was the only means for vehicles (both motor and horse-drawn) to cross the river in order to travel north or south up the coast.

it was cold when the fogs rolled in (still is) and it was cold when it rained (still is).

He charged fifty cents per auto; foot traffic was free as far as Jane DeCarly remembers. Tom King Sr. thinks the county put some money into it because it was a public service.

As mentioned earlier, the only time the Willow Creek ferry didn't run was at flood or extremely high water. Floods brought debris and trees downstream at speeds posing serious danger. At high water, horses were hitched to it. They pulled the boat, secured with cables, from the bank.

The ferry was used as a regular commute by the children at Markham upstream to go to school in Willow Creek, as this was the closest school to them. Jane DeCarly and her sister, Kathleen Rickard, along with their brother, rode it all the time as children going to school in 1914. But when the ferry wasn't operating, they had to walk over the hills to Duncans Mills' one-room school.

Alex Cuthill died in 1931. His widow and son ran the ferry for a short while. It was put into retirement when the bridge at Bridgehaven was built in 1932.

"Well, Youngster, ya did a purty good job here. It don't seem thet it wuz fifty years ago thet Mr. Cuthill run th' boat down there."

"Thanks, Ol' Timer. I went down there to look around, and I didn't realize until then how open the country is right there, so exposed to the weather."

"Yep, it can git cold an' grey down there."

"Could you two finish up here?" asked Anne. "It's closing time."

"Sure," we both said, leaving.

"Take care, Ol' Timer."

"See ya later, Youngster."

AIN'T IT AMUSING?

STUMPTOWN DAYS

River Gazette, *June 9, 1978*

For the thirteenth year in a row, it's "Rodeo Time"! It is also the thirty-second annual Stumptown Daze Parade. The first Stumptown Days originated in 1946, appropriately enough, in a Guerneville saloon. A couple of local males wanted to have a day to let the countryside and the Bay Area know that the Russian River resort area was open for the coming vacation season.

The original instigators were Red Standish and Joe Sessler. Most of the tavern operations (there was no Russian River Tavern Owners Association at the time) were for the idea. But not all were. Charlie Wong, who had the Louvre, and Frank Buchanan of River Rendezvous both said "no." Red Kerr, who took care of the slot machines for Angelo Boles at Guernewood Park Resort, said yes.

In those days, slot machines could be found in just about any drinking establishment along the river. Standish and Sessler donated one day's take from the slots to get the project rolling. Angelo Boles, the Markarians of the River Club, Bank Club owner Paul Mitchell, Lou Gori of Gori's Tavern, Bill Hurl and others donated money. Buck Buchangiani of Buck's Ranch put a full-page ad in the *San Francisco Herald Express*. Lee Murphy opened up the Grove Dance Hall for the awarding of prizes. Tom King Sr. was named parade marshal.

All together, the town's celebration provided the public with a parade, slot machines, gambling chuck-a-luck, Pickard's Carnival, a logging competition and an exhibition by the Golden Gate Fly Casting Club.

In later years, the people took to wearing "Stumptown Daze" buttons at a buck each. The buttons had a white-bearded character on them and a logo stating, "I am a 49'er." (Author's note: Humph! Guerneville didn't get started until the 1860s.)

It was about 1955 that Bill Schaadt, world-famous fisherman and sign painter, created at the request of the Guerneville Chamber of Commerce a new button and poster design. The result was "Stumptown Sam," who looked very much like a town character named Tom Cat (since departed from these environs).

Other little developments came and went with each year's festivities: the townsfolk in Gay Nineties costumes and the beard or Whiskerino contests, as well as the car caravan to San Francisco to invite the mayor to the shindigs.

The last true Stumptown Daze celebration took place in 1972 under the direction of the now-defunct Russian River Jaycees. Only the Saturday morning parade remains, now under the care of the Russian River Chamber of Commerce.

Stumptown Days Parade, 1959. Spectators would fill the streets and building balconies to capacity as various floats, like this logging truck, strolled through town.

The Echo of Bands Passed

The Paper, *September 3–9, 1982*

"Howdy, Youngster."

It was Ol' Timer sitting at the counter in Pat's Café sipping an iced tea.

"Hello, Ol' Timer." I plunked down alongside of him. "Kellie, may I have an iced tea, please?"

"Only if you two behave yourselves," she answered.

"I promise," I said.

"Howja like th' articles," said Ol' Timer, "in LeBaron's column th' other Sunday 'bout th' big bands on the river—looked purtty good ta me."

"Yes, it was a good one. Those bands must have flown in and out to make all those one-night stands."

"Yep, in them days durin' th' Depression, they was dance halls all over th' place."

"I knew of dance halls in Rio Nido and Guerneville," I said.

Kellie delivered my drink.

"Thanks, Kellie, for the tea."

"Okay. Just keep it down to a low roar," she said.

"Wal," continued Ol' Timer, "there was one at Mirabel and one in Guernewood Park."

"That's quite a few for this area," I said. "But the big bands didn't play them all. I have some photos and postcards of bands that were well known along the river that played all summer and not just one-night stands."

"Say, kin ya bring 'em down? Like ta take a peek at 'em."

"Sure, I will. I was thinking about the orchestras during the '50s who were regulars like Paul Law and Ralph Rawson at the Grove here in town."

"Well, I kinda 'member one back 'round '39 er there'bouts—was Lenny Rapose an' his orchestra. It was a fifteen-piece band an' made some good sounds."

"Hold on," I said. "I want to make some notes and get my photos. I'll be back in a minute."

"Okay. In the meantime, I'll put on muh thinking cap."

I returned and laid out a dozen pictures of mixed quality in front of Ol' Timer.

Kellie eyeballed me. "You back again?"

"I've been good. I've been good," I said. "May we have another two iced teas?"

"Okay."

Ol' Timer said, "Hey, these here pitchers are great. Where ja get 'em?"

"The photos are from Shorty Parkins and the postcards are from Thelma Pillar."

"Whoeee! Look at them get-ups: plus-four, white saddle oxfords and slicked-down hair."

"Yes, some bands were pretty fancy. The photos run close in years. You can see Rio Nido had Pete Horner in 1928 and '29, Chuck Dutton in 1930, Jackie Souders in 1932 and Lee Searight in 1933. Take a look at the postcards from Guernewood."

Ol' Timer studied the cards and flipped them over. On the back of Reg Code's card, my old friend read: "A Group of Individual Artists known by Thousands in the Bay Section. An Incomparable Ensemble. Director: Reg Code. Reed Section: Bob Harrison, Rick Guidge, Ray Anderson. Rhythm Section: Dave Olsen, Ted Walters, Jim Mayall. Brass Section: Jerry Browne, Gene Alvenn, Walt Lovegrove."

"Betcha they whipped out some purtty good music."

"It doesn't sound like they were pikers, Ol Timer."

"Ya know, now thet I think of it, I wouldn't be surprised iffen my lady friend, the one I tol' you about who was a beauty contestant back in '27, if me an' her danced ta them."

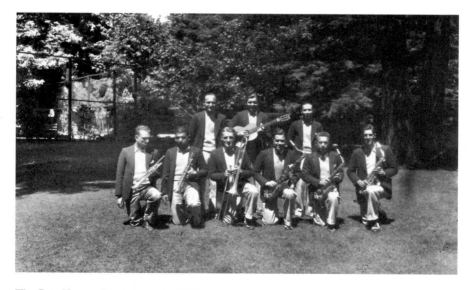

The Pete Horner Band, taken in 1929.

"You are probably looking at your past. Look at the one of Code during his third season."

"Yeah—snappy lookin' bunch."

"What bands were here during the war and late '40s?" I asked.

"Oh, I weren't 'round then. I was up in Mendocino and Humboldt Counties loggin'—doin' my part fer th' war effort."

"Can you think of any summer-long bands at Guerneville?"

"Well, now thet ya ask me I do 'member Ray Tellier and his orchestra at th' Grove. There musta been 'bout fifteen members in it; played all durin' th' '30s, maybe 'bout nine er ten years."

"That was a long booking. Well, I've got to get going to get this into *The Paper*."

I paid Kellie, who looked happy I was leaving.

"See ya 'round, Youngster."

"Take care, Ol' Timer."

Ferries on the River

The Paper, *May 14–20, 1982*

I strolled into Pat's one afternoon last week and spied Ol' Timer sitting in a booth reading *The Paper*.

"Hello, Ol' Timer."

"Oh, howdy, Youngster. Set yerself down an' join me in a cup."

Anne brought me coffee and added more brown brew to Ol' Timer's cup.

"Seen yer name in Gaye LeBaron's column a couple a Sundays ago—had sumthin' ta do 'bout a steamboat on the river."

"That was about the *Enterprise* in 1869," I said. "There were other commercial boats on the river. The last two were Bid Greene's tourist excursion from town to Rio Nido and the *River Queen*, which ran from the dam here downstream to the lower dam below Vacation Beach."

"Yep, I 'member those, but they was newcomers," he said.

I recognized the twinkle in his eyes—he was going to try to zing me with some of his knowledge again.

"Oh, yes," I said getting the jump on him. "There were two others down at Monte Rio that were used as water taxis besides tourist rides. They ran

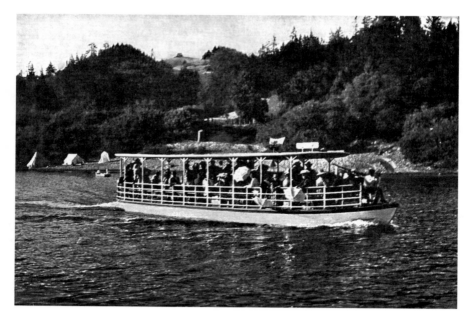

The *Sonoma* treading water in Monte Rio, circa 1912.

from Monte Rio up to the end of the railroad at Northwood, about 1910, I think."

"Yep," the white-haired man said, his eyes still twinkling. "Called the *Montrio* and the *Sonoma*."

I continued, "The *Montrio* was a stern-wheeler with a wheelhouse up above the passenger deck. It looked like a small Mississippi steamboat." I was really rolling now. "The *Sonoma* was a propeller-driven boat built in Monte Rio."

"Yer doin' pretty good, Youngster." I didn't like the way he said that.

"Anyway," I continued, "these boats could only go as far as Monte Rio because there was a footbridge across the river at Meadow's boathouse below town."

"Oh, yeah. I fergot 'bout thet ol' boathouse," he said, his eyes still twinkling.

"Okay, you old codger. What are you going to tell me? You're about as antsy as a kid at Christmas."

"Well, ya spoke 'bout all these boats what was plyin' th' river in this cent'ry. But whatta 'bout last cent'ry—I mean besides the *Enterprise*?"

Dang it all. This old crusty friend had snookered me again. "Okay, let's hear your story."

"Thought you'd never ask," he giggled.

Anne came by and filled our cups.

"Nat'rully I twern't 'round then. Pa tol' me 'bout 'em. T'was back 'roun 18 and 73, mebbe earlier. They was two of 'em, the *Quickstep* an' the *Comet*.

"Now the *Quickstep* was piloted by a man called Livreau. The creek by Surry Inn's named fer 'im. The other boat was run by Grandpa Bagley—thet's whut we kids all called 'im."

"Grandpa Bagley?" I asked excitedly. "Do you mean John Bagley, the man who named Guerneville and was the town's first postmaster?"

"One 'n' the same," said Ol' Timer.

"Holy moley. Was there anything that man didn't do?"

"Yep, thet was Grandpa Bagley fer ya, tried ev'rything. Anyways, Grandpa Bagley built his boat up in Healdsburg. On one of his trips down to Guerneville, he got run up a snag."

"Obviously," I interrupted, "it was winter because he got up to Healdsburg and was coming back."

"Yep," said Ol' Timer. "He didn't wait 'til the river got so low ta flounder on a gravel bar like King did with his *Enterprise*. But Grandpa Bagley was rescued by the *Quickstep*. It took on some a Grandpa's freight an' brought it on down ta here."

"I wonder what these boats looked like?"

"I cain't tell ya, Youngster. Don't even know whut powered 'em. Stern-wheeler? Or side-wheeler?"

Ol' Timer pondered a moment while he sipped his coffee. His white bushy eyebrows twitched.

"Jist happen ta think what th' river looked like then, no bridges, few houses, no power poles an' big trees right down ta th' river."

"Yes, it must have been beautiful—no cars, no trains. But also think, Ol' Timer, of all the timber debris floating downstream as a danger to the boats. I'd think it would be a little disconcerting to the captain."

"Not only thet, it wud be nerve rackin'," chortled the geezer.

"Well, I've got to get going." I plunked down a dime for our coffee. "See you in *The Paper*, Ol' Timer."

"See ya in *Th' Paper*, Youngster."

RUSSIAN RIVER 3019: HALF A CENTURY AS GUERNEVILLE'S EXCURSION BOAT

Sonoma County Historical Society Journal, *July 1988*

Another bit of Russian River history has been found, another part of our past has returned to the fold. As reported on these pages, Bidwell Greene's excursion boat has been brought back to Guerneville from Sausalito. This event stirred up memories, innocent mistakes and questions. Heads were scratched, photos brought out, records scrutinized and clippings unfolded. Eventually, a history was revealed.

First of all, the boat was called *Russian River 3019*—nothing else.

It all began about 1924 at the eastern end of Guerneville. Construction was done at Nydegger's Resort alongside the fence it shared with the lumberyard. Sam and Jerry Parkins, brothers to "Shorty" Parkins, were the builders. Former boatwright Frank Johnson, who ran the 5&10 store in town, gave his instructions and guidance to the men. The boat's length was twenty-six feet, nine inches, with a beam amidship eight feet, ten inches and a stern measurement of six feet, two inches. The depth of hold was thirty inches. The first engine was a Ford Model T.

A special carriage was built to move the boat from winter storage to summer usage. It was a large wooden rack shaped like a hand truck, with two wheels on the "stern" end. The front end was hitched to a truck for towing. The wheels were about five feet in diameter with one-foot-wide rims. Rims and spokes were all steel. These special wheels were made so the loaded wagon would not bog down in the gravel and sand of the beach.

During winter months, the boat was stored at Cliff Marshall's, now Noonan's Garage on Fifth Street. The carriage, like a piece of farm equipment, was not licensed for use on public roads. The trip to spring launch and fall retrieval was taken as sneakily as possible to avoid the highway patrol and the possibility of a traffic ticket. When stops were made by traffic officers, towers did some fast talking, apparently with success. No traffic citations are known to have been issued. When this maritime circus was hauled on the pavement, the steel wheels created a noise that could be heard blocks away. The main route was straight to the beach.

During the early years, Jerry Parkins captained the vessel most of the time, with brother Sam filling in occasionally. It was an easy-driving, easy-riding boat.

A glimpse of the *Russian River 3019* at its full capacity during the height of the summer season, taken in the 1950s.

The seating capacity initially was about twenty-two passengers placed around the inside of the bulwarks. Protecting these sightseers from summer sun was a canopy of canvas, which ran the length of the boat and was supported by the frame on ten stanchions.

For the next eight summers, more or less, the Parkinses navigated the river between Rio Nido and Guerneville.

About 1931, a man came down from the hills behind Armstrong Park to become owner-captain of *Russian River 3019*. Thomas Bidwell Greene, more commonly known as "Bid," went on to pilot the craft for the next twenty years. During those years, Bid made a few changes in the boat. He disposed of the soft canvas canopy, replacing it in 1941–42 with a permanent wooden roof on twelve stanchions. At some point in the early '40s, he replaced the old engine with a Star Marine engine made in Oakland. He raised the sides (bulwarks) three inches and increased the seating capacity to thirty-two.

Bid always kept to his schedule, and passengers or no, he left on time. The first trip of the day left the Guerneville pier at 10:00 a.m., stopping at Roland's Beach (about halfway to Rio Nido) for more passengers and arriving at the Rio Nido dock about 10:30 a.m. The return trip was a mirror

Russian River 3019's captain Bidwell Greene, with passenger, taken in the 1950s.

of the upstream voyage. The fare was fifteen cents one way, twenty-five cents round trip. Eventually, it was raised to twenty-five cents one way, fifty cents round trip. The last day cruise ended at Guerneville around 6:00 p.m.

Bid's night cruises were scheduled according to the dances at Guerneville and Rio Nido. These were held on the weekends and on Wednesday evenings. He would make only one trip, though. If the dance was at Rio Nido, he would go up and wait for it to end and then make the trip back. It made a pleasant trip on warm summer nights when the dark river was still and you could hear an occasional fish jump and slap the water and sometimes see in the boat's single headlight startled turtles fall off logs into the water.

On many occasions, locals also rode the boat for pleasure. George Clar courted his future wife, "Mike," on his friend's vessel. A young George Guerne rode with his future wife, Hazel, and friends. They would get about two or three hundred yards upstream and he would pitch her into the drink, following shortly himself with the likes of Bun Bryans, George Denise and Stit Pool.

During the 1950s, Sam Pullaro and other teachers took the kids of Guerneville's summer school on an annual field trip on *3019*. The last year for the school trip was 1959.

As "Captain" Bid chugged up and down the summer river, dodging swimmers and other boats, the problems of running *Russian River 3019* got worse each year. Insurance rates rose, while kids were throwing mud and water bombs as the vessel passed. In 1960, Bid sold his business and boat to Andy and Mildred Bacci for $4,000. During the first year they owned the boat, the Baccis completely overhauled it. They pulled out the old engine, replacing it with a new Star-Machine, but left the old transmission. Bid had fiberglassed the whole bottom up to the waterline, and the Baccis finished

it by fiberglassing up to the gunwales. The ribs were all dry-rotted in the corners, so those were replaced and reinforced with metal brackets made by Cliff Marshall. The final touch was the painting done by Mildred's brother Elmer Rogers. The colors were always dictated by tradition—a cream yellow and red trim exterior and a navy gray interior.

The Baccis hired college boys to run the boat during the week and operated it themselves on weekends. This method of operation helped a couple young men get through college. That seasonable student-labor pool was one of the main reasons the Baccis bought the boat.

The Baccis kept *Russian River* in good repair and repainted it every year. But they had problems similar to Bid's—even more so. Mildred wrote, "Kids started throwing rocks from the bridge, jumping from swings and splashing people, also cutting the line we tied the boat with and let it drift down to the dam." The last year they owned it, the vessel was vandalized; the shift lever on the transmission, the steering cables and the motor were all damaged.

Andy's brother Dante ran the boat during the last years of the Bacci ownership. One day, two kids in a rowboat were throwing mud at the touring boat. Dan yelled at them to stop, but to no avail. He got even with them though, as he hit the rowboat amidship and put a big dent in it. Dan figured they must have had the boat out without their parents' permission, as he never heard anything further about the incident, though later somebody again vandalized the *3019*.

The boat finally had become too much trouble. The Baccis ran newspaper advertisements asking $5,000 for the forty-four-year-old craft. They eventually sold it for $4,500, passing ownership in 1966 to the Boderos family of Marin County.

The summer of 1970 was the last one on the river for *3019*, again manned by college boys. The very last run was after Labor Day, an evening cruise for the Russian River Jaycees, followed by a beach party. The two college kids joined in, not caring what happened because it was the end of the season. They, and the boat, were leaving.

Some of those on board for that last trip were Bill Burke, Bill Guerne, Hans and Barbara Hoffman, Dawn and Margaret Pedrioa, Jim McCaulay and John Schubert. There were no swimmers or other boats around; they had the river to themselves. The boat made it up to Rio Nido at quick speed and turned around. About halfway back down the channel to Roland's Beach, the boat was nosed up on a smaller beach. After a party, everyone loaded back on for what was to become a precarious trip back to Johnson's Beach.

There were various attempts to lighten the load by casting people over the side. Potential jetsam sought refuge on top of the canopy. Whoever was at the helm upped the speed toward Guerneville. Just before the boat reached the safety of the beach, someone demonstrated how to abandon ship. The boat rocked from port to starboard, almost shipping water. When the bow touched shore, it was Iwo Jima—people off first, rats second.

Thus ended the last trip for *Russian River 3019*. The boat was later hauled on its carriage—steel wheels and all—to Marin.

CRUISIN' MAIN IN MY 1912 OLDSMOBILE

The Paper, *October 12, 1979*

I was heading to work last Tuesday after our first rain and saw that a car had slid off the road. This incident started a chain of thoughts leading me to ask myself, "Self, what were the first cars in town?"

That evening when I was home, I dug out my interview notes of the Ol' Timer. Ol' Timer said the first autos were Jack Strode's 1903 Oldsmobile, the Swarm brothers' '07 Franklin and the Drake brothers' '07 Everett-Metzger-Flanders, or EMF.

Jack Strode's Olds was a real prototype automobile. He bought it from Schillings' in Santa Rosa. It had a tiller for steering and was powered by two cylinders. To start this mechanized cart, the driver would crank the engine not from the front but from the side—a real sidewinder.

"When the car quit in the middle of a trip, everyone would just sit there until it wanted to start," said Ol' Timer.

The 1907 Franklin belonged to Andy and Bill Swarm, who lived off Old Cazadero Road by the Devil's Ribs. It was an air-cooled contraption with a "radiator." The radiator was false so the car wouldn't look strange to the buying public.

The EMF, also of '07 vintage, was owned by the Drake brothers, Ben and Fred. They said the initials stood for "every mornin' fixin's." 'Nuff said.

But there was one vehicle that roamed around the river some twenty years before these three cars appeared. It was back in 1881. A little article appeared in the *Santa Rosa Republican*: "R.B. Lundsford appeared in Guerneville with his newly invented vehicle, a self-propelling carriage,

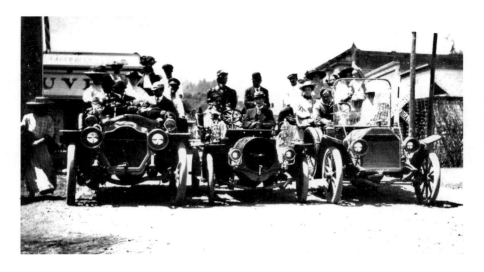

Town gents and ladies piled high in the modern technology marvels, taken in 1912. *Left to right*: the Everett-Metzger-Flanders, the Franklin (note the false radiator) and the Pierce.

something between a bicycle and a preambulator. It needs a little remodeling when he will try it again."

Then Lundsford, local mill owner, put this fabulous "carriage" away for two years. His next appearance was in Santa Rosa, where he created quite a stir running around town with his foot-powered "quadracycle." A week later, he made another test run on the road from Guerneville to Healdsburg.

With these three sojourns (and probably along with many others) accomplished or recorded in local papers, Lundsford retired the four-wheeler, at least from public comment.

I often wondered about the potential of this velocipede. Gottlieb Daimler and Karl Benz didn't invent their petrol-powered carts until 1885–86. Just how close did Guerneville come to being the birthplace of the automobile? I tremble with excitement at the thought.

TALL TREES, TALL TALES

The Paper, *August 6–12, 1982*

It was one of our hot July days. No sea breeze was coming up the river. Guerneville just sat in Big Bottom cooking away. When the temperature was pushing one hundred degrees Fahrenheit, I decided to head for the local natural cool—Armstrong Park, also known as Armstrong Woods, Armstrong Grove and, bureaucratically, Armstrong Redwoods State Reserve.

Anyway, I parked at the entrance and strolled past the Tripod Trees. I had passed the Parson Jones tree when I came upon Ol' Timer, wearing a gawd-awful touristy Hawaiian shirt and walking shorts. I chuckled at his spindly bowlegs sticking down from his barrel body.

"Hello, Ol' Timer."

"Howdy, Youngster. What brings ya out here?"

"The same reason you are out here—seeking refuge from the heat."

"Right ya are."

We started strolling along the path toward Burbank Circle.

"It shore's nice here even wi' this here second growth."

"Second growth?" I looked around. "Golly whompers, look at the stumps here. As many times as I've been out here, I never noticed the stumps because of the trees."

"Yep." He had a smart grin on his face. "Them stumps is hardly noticed 'cuz o' th' moss 'n' ferns growin' on 'em. The tourists don' see 'em—they's just here ta look at the big trees."

"I feel like a tourist in my own town," I said, chagrined.

"Well, least ya know I'm tellin' ya th' truth an' not sum cock-a-mamie story."

Cock-a-mamie? I never hear him use that kind of expression.

"When me an' Frank Gianoli was hand loggin' back in th' '30s, we cud whip some big fibs out on a man 'bout these here redwoods."

We sat down on a fallen log in the heart of the cooling glen. We took in the sounds and shadows. It reminded me of what one man wrote: redwoods are not looked at, they are experienced.

Ol' Timer's eyes flit back and forth over the scene—white eyebrows twitching.

"What kind of fibs?" I asked, bringing him back to the present.

"Oh, we'd tell th' pilgrim thet th' first fallers wud say them trees shore punched a big hole in th' sky. Why, they was so tall it took a man seven days ta see th' top, but if seven men looked at th' same time it took only one day."

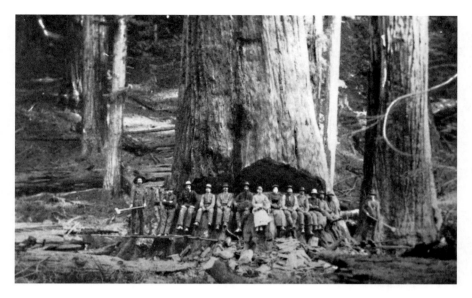

The trees that inhabited the Russian River Valley were so massive that twelve men (and women) could stand shoulder to shoulder to span its width, as seen here. Imagine cohabiting with such magnificent giants.

We both chuckled.

"An' they ain't nuthin'. Them trees was 'big aroun' thet it took two liars ta believe one."

Ol' Timer was perking along pretty good.

"How long did it take to fell a tree in the old days?"

"Well, they din't have no saw big enough in the early times, so they axed 'em. They's a time two men was choppin' on a tree fer a week before they discovered a man was chippin' fer eight days on th' other side."

Yes, he was perking along pretty good.

"I heerd one fella, when he seen one they was down, say, 'Th man what cut thet tree down is a damn liar!'"

"Hey," I laughed, "that was a good one."

"Ha! Thet fella was pretty close ta th' truth. I 'member as a youngin' seein' them big logs."

"How big were they?"

"They was sooo big it was sunny on one side an' rainin' on th' other."

"Whoa," I said. "You are stretching my imagination might thin."

He gazed up through the tops of the redwood spires. You could see his brain trying to conjure up another homespun tale. A smile creped across his face.

"Then they was th' time a tenderfoot was walkin' 'round one of our felled trees an' got lost fer two days in th' branches."

"Now, that I can believe, Ol' Timer."

"Well after th' logs was cut up, the bull whackers wud come in with their teams of ten er twelve bulls and snake the logs out a th' woods to th' mills. They'd get ta yellin' an' hollerin' iffen their bulls twern't movin' good. They'd jump up on the bulls an' walk up an' down the back of 'em leapin' from team ta team yellin' like all the demons in China was loose. They swore s' hard th' air'd turn beet red an' th' bark was scorched offen young trees—an' that was without repeatin' a single swear word."

Ol' Timer was getting excited listening to himself talk. I got to giggling watching his eyes light up under his bushy white eyebrows.

"An' after all th' haulin', the mills had so much wood ready ta cut they ran thirty hours a day forwards an' backwards, sometimes a couple hours sideways fer good measure."

Listening to him create tall tales was pure enjoyment. It was light humor seasoned with chuckles, chortles and guffaws. He finally tired of sitting.

"Come on, Youngster. Let's go commensurate wit' th' woods."

We rose and strolled through the forest and afternoon cool.

THE GUERNEVILLE NINE

The Paper, *date unknown*

It's October, and school is underway, autumn has arrived and the World Series of Baseball caps another season of "play ball!"

Baseball has been played by Guerneville teams against other towns for over ninety-five years. The earliest known game took place on May 8, 1881, at Guerneville between the local boys and Fulton; the visitors lost by 11 runs. Three weeks later, they went to Healdsburg and beat them by 4 points.

The following year, a formal club was organized with J.P. Strasburgh as president, Walter Murphy as secretary and D.L. Cobb as captain. The Guerneville Baseball Club played its first game against a makeshift home team called the Guerneville Unknowns. Score: Stars 11, Unknowns 5.

Up to now, our team's record was 3 wins to 0 losses, and here baseball fades from Guerneville for ten years.

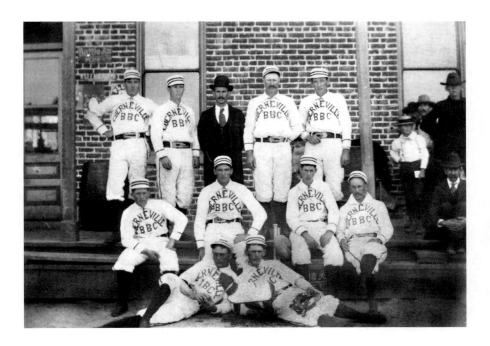

The Guerneville Baseball Club, circa 1893. *Top row, left to right:* Willard Cole, Jim Pells, Charles Pool (manager), Jeff Smith, Bob Garner. *Middle row:* Ben Klink, Will Cole (Willard's twin), Jack Brown, Willard Bagley. *Bottom row:* Frank Wescott, Steve Klink, "Ripley" the mascot.

In 1891, baseball was revived by the formation of the Guerneville Gravel Scratchers to play against the Forestville Coyotes. Again the river boys came out on top, 9 to 4. The following week, they played Santa Rosa, but the Santa Rosa paper failed to report the score (possibly they lost?).

But Guerneville's luck couldn't hold forever. A fateful day was July 25, when the Gravel Scratchers bit the dust by losing their first game to the Forestville "nine" by 2 runs.

Be that as it was, the Guerneville "shaggers" stayed together and by 1893 were formally attired in baseball uniforms. Their win/loss record is nonexistent, and again baseball dropped from sight.

At the turn of the century, a third club was created. Members Jack Brown (catcher) and Bob Garner (first baseman) from the old organization joined Dick Cole (pitcher) Bert Klein (second basemen), Jim Woods (shortstop), Ed Peugh (third baseman), Charles Brown (left field), Archie Robinson (center field), A. Hammerslaw (right field) and George Gibson (relief).

In a game against Duncans Mill's team made of Ed and Hy La Franchi, John Berry, Oscar Baker, Billy Worthy, Roy George, George Moore and Joe DeCarly, the "upstreamers" outscored the "downstreamers" 11 to 4.

Sil DeCarly, brother of Joe, was the finest pitcher on the river. As one of the local old-timers remembers, "He could snap a ball at damn near right angle to home plate." Sil tried out for the San Francisco Seals ball club but came home when the manager told him to go out into the center field and catch flies.

The team most fondly remembered was of the World War I era. When the team came home from away games, they "came home with the broom," which was most of the time. A new broom went to the winner—"a clean sweep."

The men were good players but would not take to discipline. Jack Starett and Henry Brown were catchers, and both could zing the ball to second base without getting out of a squat. New umpires were told that when a player broke first to try to steal second they should stand aside because of the speed with which they threw.

On the receiving end at second was Bert Klein, who had good strength and was durable. "Beany" Wells was pitcher; he used to get drunk on Saturday nights, but the boys would get him sober enough to pitch by 2:00 p.m. on Sunday. Ralph "Banty" Belden was literally "short" stop. Other players were Rand Starrett, (second baseman and later a justice of the peace), Glen Laughlin, John Shoemake, Ben Wescott and Vern Clark.

During the following decade (the Roaring Twenties), the team's outstanding players were Lou Gori, a big man (great at third), and Frank Montecelli, pitcher par excellence. Buster Clar told of when he was catcher one time for Frank and he could hardly hold the catcher's mitt. One time when they were about sixteen years old, the two went to San Francisco. At Golden Gate Park, Frank "sort of oozed into a boys' game." After zipping a couple of pitches past everybody and over the plate, the umpire told him that he couldn't play: "too dangerous." He could have been in the Majors, like Sil DeCarly, but he also didn't take to formal training.

Bert Laws was another good pitcher.

After World War II, the Guerneville merchants created another team and had bleachers built where the Rodeo Grounds are now,[7] but that story will have to wait until the next baseball season starts.

7. The original Rodeo Grounds were located roughly half a mile north of Guerneville on Armstrong Woods Road. The Rodeo Grounds were moved to Duncans Mills' Parmeter Fields in the 2000s.

Part III

THE SHADY SIDE OF THE RIVER

CAZADERO STAGE HOLDUP!
Yesterday & Yesteryear, *December 2012*

Note: A stage route traveled from Cazadero to Point Arena. Leaving the Cazadero railroad station, it went up Fort Ross Road ten and a half miles. At its junction with Seaview Road, the route went to Fort Ross and continued north forty-four miles to Point Arena up the coast.

It was April 1892. Over in Sacramento Valley, in an Orland saloon, two men were drinking and struck up a conversation. One was Joseph Franklin Haney, age twenty-four. He was five feet, nine inches and well proportioned, with gray eyes, brown hair, a moustache and medium complexion. He was a brick mason originally from Indiana and had been in California eight years. The second man was Charles N. Carter, also known as Charles Murphy, age twenty. He was short at five feet, four inches. He had blue eyes, light hair and a fair complexion. He was an out-of-work laborer from Montana.

Their conversation centered on work. Haney had just quit working on a ranch and pulled his wages. Murphy said he was broke and out of work. Haney told him to go see his former employer. (Murphy followed up on Haney's recomendation but failed to get a job.) Sometime later, Murphy made a statement about how hard it was to make any money working on a ranch.

He flat out told Haney he was ready to do anything. He suggested that they go to Fort Ross, an area with which he was familiar. Haney had not heard of the place. So the two made a journey across the mountains to

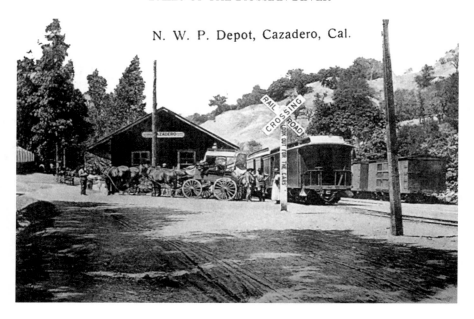

A stage at the Cazadero Station, post-1900.

Round Valley, came down to Ukiah and then on to Healdsburg.

It was at Healdsburg that Murphy wanted to rob a store to acquire some guns. For some reason, the plan was not carried out. Haney then wanted to drop the whole idea. Murphy got mad and insisted Haney come to Fort Ross with him, saying that's where he could get all the guns he wanted.

They made their way to the coast and Fort Ross. During the night of May 16, Murphy broke into a house and stole a Winchester rifle and a double-barrel shotgun, plus ammunition, cigars and whiskey. They proceeded east toward Cazadero over Fort Ross Road to the South Fork of the Gualala River and then went up the road one mile farther to Turner Canyon, just below Brain Ridge. By now it was daylight. The two secreted themselves along the road and tied kerchiefs over their faces. Murphy cradled the rifle while Haney hefted the shotgun.

It was the morning of May 17. The Point Arena–bound stage was loaded up in Cazadero with eight passengers, one a young lady, plus mail, a Wells-Fargo strong box, luggage and a small amount of freight. The driver, Theodore Howard, got the stage underway to Fort Ross and points north.

At the same time, the two armed men selected their positions along the road

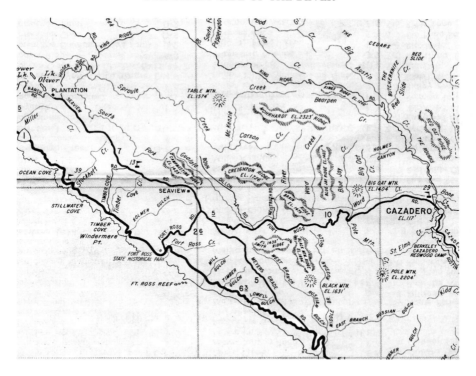

The robbery took place on Fort Ross Road, between the towns of Cazadero and Meyers Grade Road, just below "Brain Ridge."

and waited for the stage. When they heard the coach, Murphy called out, "There she comes—take your place." Haney made his way to the side of the road.

As the lumbering coach came up, Murphy grasped the bridle rein of one of the horses with his right hand and with his other coolly leveled his rifle at the head of the driver. He ordered the driver to stop and climb down from his seat. The passengers were ordered to vacate the stage. When the two noticed that one of the eight passengers was a young lady, Murphy told her she need not step down. But she wished to and took her place alongside the other passengers.

Howard, the driver, was ordered to search the passengers for valuables but not to take anything from the girl. One man complained that he only had $0.75. He was afraid the robbers were going to take his handkerchief, so he slipped it into the girl's pocket. A total of $50.00 was lifted from an old gentleman. The Wells-Fargo express box was taken down and shaken, but thinking it had no coin in it, neither Murphy nor Haney opened it.

The total of the take from the passengers was $70.55. They split it evenly between them.

Their crime having been executed, the coach was ordered to go on. With the stage out of sight, they hid the guns and handkerchiefs in a gulch running back to Long's Place off the Cazadero–Fort Ross Road.

Like Black Bart after his holdups, the duo struck out on foot for Guerneville and points east, going through Cazadero.

On that same Tuesday, Cornelia Trosper wrote in her diary, "The stage was robbed this A.M...Two strange characters passed this evening."

Immediately, the sheriffs' offices of Mendocino and Sonoma Counties, as well as the nearby towns, were telegraphed of the robbery. Mendocino sheriff J.M. "Doc" Standley came down the coast, and Sonoma County deputy Gould of Fort Ross, after questioning the robbery victims, retraced the duo's trail. Deputies Tombs and Fine went out from Healdsburg.

Murphy and Haney tramped their way over Cazadero Road and ridges and arrived in Guerneville the next day, Wednesday the eighteenth. The pair split up, with Murphy staying in town at the Grand Central Hotel.

Murphy was arrested that Wednesday morning in the hotel by Standley. He gave his name as Ernest T. Battolph and said he had come down from Ukiah on Monday. He gave conflicting stories, and under continued questioning, it came out that his true name was Charles Carter. The sheriff managed to get from Battolph/Murphy/Carter a partial confession before starting on the trail of Haney.

As Haney left town, he saw Sheriff Standley but didn't know who he was. He continued east, arriving in Santa Rosa on Thursday at about 2:00 a.m. He hopped a train at Melita (east Santa Rosa) at 2:00 p.m. heading toward Sacramento. He tried to do most of his traveling at night.

For the next five days, Haney searched for work in Yolo County. He was on the train to Woodland when it stopped at Black's Station. Haney was just beginning to feel safe until he instantly recognized Standley standing in front of a store near the station. The next thing he knew, the Mendocino sheriff and Sonoma deputy Fine were looking down at him in his coach seat. That night, Haney was in Santa Rosa and the Sonoma County Jail. As he had not been involved with the law before, Haney was fully cooperative with Sheriff Standley and Sonoma County sheriff Mulgrew when questioned about the times prior, during and after the robbery.

The next day, May 25, Carter and Haney were arraigned before the court on felony charges. A preliminary examination was conducted by Justice Brown. He held both men to answer to criminal complaints in

superior court.

After the examination, the officers commented that Carter was "one of the coolest hands at highway robbery that [had] loomed up on the criminal horizon for several years." It had been alleged that Carter had been involved in stage holdups in Arizona and Nevada. It was also stated that Carter had been arrested in Glenn County for striking a man over the head with a revolver, nearly killing him.

At the same time in San Francisco, a U.S. grand jury was held at the U.S. District Court for the Northern District of California. Upon testimony of Theodor Howard (stage driver), George Bates (one of the passengers) and J.M. Standley (sheriff of Mendocino County), both suspects were indicted for intent to rob U.S. mails. An arrest warrant, with bail set at $5,000, was issued by the federal court on the two and delivered to the Sonoma Superior Court on May 28. In turn, the superior court ordered Sheriff Mulgrew to deliver the defendants to the U.S. marshal.

Haney and Carter were arraigned before the U.S. court on June 9 and pled guilty. On June 11, they were sentenced to two years hard labor and committed to California State Prison, Folsom. They arrived at Folsom on June 14, 1892, and were discharged six months early on February 11, 1894, by reason of "good behavior."

What happened to the stolen money? Carter had little time to spend his share; he was arrested early. Haney spent most of his loot traveling around trying to find a job.

How did Sheriff Standley spot Haney? Haney was described as wearing a light gray hat at the robbery. He was still wearing it when the train stopped at Black's Station. Standley asked him why he was still wearing it, and Haney stated he was afraid to be seen throwing it away.

[Sources: Sonoma Democrat; personal correspondence with Gary Rogers, dates during 1976; Sonoma County Archives, Santa Rosa; California State Archives, Sacramento; National Archives—Pacific Region (San Francisco)]

JUDGE ELLEN FLEMING: SONOMA COUNTY'S FIRST LADY OF THE BENCH

Sonoma County Historical Society Journal, 1990

Some people receive their due because of their success in achieving their goals or because they persevered in times of adversity and championed over their foe. Others were in the right place at the right time and made the best of the situation. This happened to Ellen (Linscott) Fleming of Guerneville.

Ellen Davenport Linscott was born in San Francisco in July 1909 but was raised in Los Angeles. She enrolled at UCLA in 1928 and later transferred to UC–Berkeley. While at Berkeley, she met a young man on campus, Lee Fleming, and they became engaged. Upon their graduation, Lee went to New York to play in Horace Heidt's orchestra. Ellen followed. It was March 1932 when they were married in New York City.

The Flemings came back to the West Coast in 1935 and arrived at the Russian River resort area. On April 12, 1939, J.P. Schaeffer resigned as judge and Redwood Township's justice of the peace. Lee Fleming was appointed to complete Schaeffer's term; Ellen was made court clerk. The area of this court's jurisdiction was from the Sonoma Coast (the middle one-third) inland to about Hacienda Bridge. Lee ran for election to continue his tenure as judge in August 1942; there was no opposition.

World War II was underway, so Lee volunteered for the U.S. Marine Corps in the following October. He submitted his resignation to the board of supervisors, which granted his request. The bench was vacant.

Ellen had proved herself to be more than capable as court clerk. The supervisors appointed her, Ellen Fleming, court clerk, to be Ellen Fleming, justice of the peace, the first female judge in Sonoma County history.

Judge Fleming presided well those months of November and December. On January 4, 1943, the supervisors appointed her again, limited only in time to Lee's return from the Pacific.

The attorneys who appeared before her accepted the way she conducted her court and her decisions. There were few disqualifications; most were due to her personal relationships with or knowledge of one or both parties involved, and she disqualified herself.

As with any court, there are humorous anecdotes that stand out in memory (and seldom get into print). Her Honor had her share. One day as she was walking up Main Street in Guerneville, she passed a sheriff's car with two men

sitting in back. They wolf-whistled at her, made complimentary remarks about her appearance and asked her for a date. As Ellen later related to her daughter, Lee Ellen Loundigan, "When they saw me sitting on the judge's seat, their jaws bounced on the floor."

On another occasion, Her Honor told this writer, "Two prostitutes were arrested for being nude with a soldier, and the arresting deputy said during court that they didn't have any clothes on. One of the gals said, 'That's a lie! I had on my brassiere!'"

Judge Fleming heard them all: small claims, civil suits, jury trials, criminal charges, the bad along with the good, the sad with the funny, stranger against stranger, friend against friend.

Near the end of 1944, Lee returned from the Pacific war zone, discharged honorably from the U.S. Marine Corps. Ellen presented her resignation to the board of supervisors, and it was accepted. At the same time, the board reappointed Lee to the bench on December 27, 1944, effective January 1, 1945. Lee subsequently ran again for the judicial seat and again was unopposed.

After eleven years and choosing not to seek reelection, Lee and Ellen left the Guerneville Court in 1950. In 1951, they bought an insurance business from local real estate broker Jack Wright. The Flemings remained in this business for thirty-two years. Lee passed away in 1973, but Ellen continued on until Tom King Jr. of Guerneville bought the business in 1982.

During her decades "on the river," Ellen Fleming was a friend to all in every sense of the word. She was actively involved in the chamber of commerce, Blue Birds, March of Dimes, PTA and civic celebrations, Stumptown Days and Fire Mount Pageant.

Reaching back fifty years via township, supervisor and court records that are nearly nonexistent and by interview to re-create the situations and person has not been easy. All court records have been destroyed due to age and the demise of the justice court in 1964 with the expansion of Sonoma County Municipal Court. Only about two dozen documents survive from Ellen's tenure as judge.

Ellen Fleming presided for two years and two months in court—documented—and was appointed twice to the bench. To add to her distinction, there is this addendum: the Flemings were if not the first then among the first couples in California where both wife and husband have been judges in the same court.

It would be another thirty-eight years before a woman would sit as a judge in a Sonoma County court.

JUDGE TRIED FOR MURDER OF TRANSIENT

The Paper, *October 16–22, 1981*

Occasionally, fate or luck will turn with a suddenness that literally jerks you, sometimes from good to bad (or vice versa) and from seconds to hours. A good example of this is an auto accident you are involved in or dropping a quarter in a slot machine and hitting a $1,000 jackpot. How quickly fate turns.

Such a case happened to Guerneville's justice of the peace, Richard B. Brown, on October 18, 1903. It was late afternoon when Charlie Hansen, superintendent of Korbel's Mill in Pocket Canyon, was driving along Pocket Road with ladies in a wagon. An old man with a blanket-roll slung across his back was plodding along in the dirt road. The horses took fright of him.

Hansen berated the man for scaring the steeds. The man responded in like manner. One step led to another until the gent challenged Hansen and made a motion as if to draw a pocket pistol. Hansen, thinking of the ladies' safety, drove off with the man cursing at them as they disappeared down the dusty road. The ladies were greatly disturbed.

When Hansen arrived in Guerneville at dusk, he looked up Judge Brown and told him of the traumatic event. Both men promptly mounted horses and returned to the scene and then went to Elijah Shortridge's home in Pocket Canyon (at today's Fisher Stove Company).[8]

Night had fallen, and lanterns were lit. Lige joined them. While Hansen and Brown searched the scene for clues and tracks of the abusive wag, Lige went down the road and found footprints leading to an old abandoned cabin buried in the redwoods of Oregon Canyon. Lige returned and got the two men to go to the cabin.

The men surrounded the dark, foreboding structure. Hansen, holding his lantern high, looked through a vacant window frame. In a corner of an empty room was a sleeping form in an overcoat on a blanket. Brown circled around the cabin and joined Hansen. Hansen set his lamp on the floor, and the light played across the old boards of the dark room.

The form stirred and sat up. It was the old man. He swore, asking what was going on. Brown told him to sit still and that they were the law. The man made a quick gesture. A shot boomed in the cabin—he fell over and groaned. Brown had fired the shot from behind Hansen. They loaded up the

8. Today's Howard Evan's Lumber Mill, roughly four miles west of Forestville.

severely wounded man and went to town. They woke up Dr. Cole to render aid to the transient. His work was to no avail.

The following day, a coroner's jury was assembled of all local residents to hear the facts. They exonerated the "posse" of wrongdoing.

The district attorney, C.H. Pond, thought otherwise. Justice Brown was arrested, charged with manslaughter and released on a $2,500 bond. About a week later, Justice of the Peace Provines of Healdsburg rode down to Guerneville and conducted a preliminary examination. After testimony was given, Provines held Judge Brown to answer to the charges in superior court in Santa Rosa.

The case proceeded through November and into December. On December 22, Judge Burnett of the superior court called a jury to hear the case of the *People of the State of California v. Richmond Benton Brown*. Evidence was taken for two days, and then the case was given to the jury. That evening, the jury reached a verdict. All parties were called to order by the bailiff as the judge took the bench.

Judge: "Mr. Foreman, has the jury reached a verdict?"

Foreman: "We have, your honor."

Judge: "Please hand the verdict form to the bailiff."

The bailiff took the form and gave it to the judge. Judge Burnett studied the single sheet of paper for correctness and then handed it to the clerk to be read out loud.

Outside of his birth, this would be the most important minute in Brown's life. Brown didn't wake up on that October 18 with the thought of killing a man. But before that day was finished, he had. For the past one and a half months, his fate had been in the possession of others.

Guilty or not guilty? What would fate cast to him now, in this next minute?

Judge: "Will the defendant rise and face the jury. Mr. Clerk, read the verdict."

Clerk: "In the superior court of the County of Sonoma, State of California. The people of the state of California, plaintiff, against R.B. Brown, defendant. We, the jury, find the defendant not guilty. D.B. Bremner, foreman. Dated, December 24, 1903."

What nicer gift could fate have given him on Christmas Eve?

GUERNEVILLE'S WOODEN JAIL

The Paper, *February 5–11, 1982*

It was a Monday, January 4. The New Year's weekend and holiday season had passed. I was sitting in Pat's Café nursing a cup of jamoca (and teasing the waitresses) when Ol' Timer stumbled in—drenched.

He plopped down alongside me at the counter and ordered a cup of java. His knit watch cap and mackinaw sparkled with rain. Big drops hung from matted silver hair sticking out from under his soaked cap.

This wet one clutched the cup with gnarled hands and slowly brought the hot vessel to his pursed lips. He squinted his eyes closed, white eyebrows knitted as he sipped.

The wish for warmth satisfied, he turned to me.

"Howdy, Youngster."

"'lo Ol' Timer. Gad, you smell like an old wool blanket."

He chuckled, "Shud smell like a drowned rat."

"Where have you been?" I queried.

"Been walkin' 'round town," he answered. "Been checkin' th' height of th' river behind th' sheriff's office. Boy, them deputies shur been busy this weekend."

"How's that?" I responded.

"Well, they wuz goin' 'round New Year's keepin' everybuddy in line. They put one fella in th' jail back there," he chortled. "Man, wuz he mad bangin' an' rattlin' 'round in there, but he twern't goin' nowheres. It's a strong cell, a lot better 'en the ol' ones we used ta have. Didja ever heard of one made of wood?"

"Yes," I answered. "It was located just up the Strip across from the lumberyard."

"Yep. Thet's where it wuz. It wuz a ruff-lookin' thing. Walls were made out a' two by eights in three er four layers."

"How long ago was this?"

"Oh, 'bout 1910 to 1920. Don' 'member any windas in it. Had a kinda small door in front with a small open winda—had sum bars 'cross it."

"Well, did it have any light in it?" this writer asked. "I imagine it was painted white or something of the like. Was there any water in it, bed, bench, toilet or what?"

"Heh, heh. It was as plain as a wood box could be. Twern't no light, no water, no paint, no nothin', 'cept an ol' mattress they all slept on. Twern't supposed ta be no hotel room."

I asked, "Did anyone try to escape or were they harassed by the people passing by?"

The Guerneville Jail. Note the cursive "graffiti" on the face of the building.

"Can't say as I 'member ennybody 'scapin'. Never heard of it neither. As fer harassin'—it weren't ennythin' serious like. Shur there wuz some joshin' but no meanness by it."

"I imagine there were some regular visitors," I interrupted, "that spent time in there just like now over at the county jail. We know some inmates on a first-name basis; they are constantly getting picked up by the local constabulary."

"Shur there wuz," he chortled. "There wuz Dan Thomasen an' Cutler. They wuz both rousers."

The old wag sipped his coffee. Then Ol' Timer's eyes twinkled and he got to giggling.

"Now what?" I asked.

"There wuz one time when I wuz walkin' with muh paw up the railroad tracks pas' th' ol' hoosegow. Cutler got throwed in fer over doin' his hooch as usual. Well, he wuz lookin' out—his face nearly filled th' small winda—when he commences to caterwallin' to Paw, 'Julius'—thet's Paw's name—'Julius, get 'em ta let me out. I been here all night.' And Paw tol' him, 'Let yerself out, ya damn fool. The door ain't locked!'"

The old geezer darn near spilled his coffee with his laughing.

FIRE OF 1919

The Paper, *March 28–April 3, 1980*

I was sitting in the café one evening by myself. Most of the diners had left; one other customer was lingering over her dessert as the waitress cleaned up after the day. My half-filled cup of lukewarm coffee was staring back at me when the front door swung open and Ol' Timer, with knit cap and mackinaw, shuffled in.

"Watcha doin' here this late, Youngster?"

"I was going to ask you the same thing, Ol' Timer. I'm just sitting here ruminating over Guerneville's present and past."

"Watcha discover?" he asked.

"Oh, nothing really very much," I replied.

"Well here's something," and he laid out a bent postcard on the counter in front of me. At the bottom was printed "Guerneville Fire—Sept 25, 1919."

"Where did you get this?" I asked excitedly. "I've never seen it before."

"Oh, I jus' hung on to it since the fire. I was there when it happened, had a room at the Louvre. It was blamed on arson."

"Arson?" I was startled. Here was a good story. "Okay, now hold it—let me get this all from the beginning. Who, what, why and all that stuff."

"Hol' on, boy. You'll get it all, don' get so blamed excited."

I fetched a paper napkin and dug out a pen. I was ready to report an eyewitness account like Jimmy Olson of the *Daily Planet*. "Shoot," I said.

Ol' Timer got his cup of java, took a sip and proceeded with his tale: It was 1:00 a.m. on September 24, 1919. Newton Lark, owner of the drugstore, gave the first alarm, which was appropriate as he was fire chief. He lived right behind the stores that burned. Newt pulled out the hose cart and chemical cart from the fire shed located in the middle of the block. The town didn't have a fire truck yet.

The fire broke out in the back end of the hardware store, near the back end of today's Otto Bakery.[9] Ol' Timer ran yelling, "Fire!" Hugh McFadden yelled, "Fire!" Everybody was yelling fire.

The days prior to the fire, Hocker and Cannon, renters of the store, were seen taking out good stock and leaving old stock. Just before the fire that night, they were again seen removing goods and putting them in their 1915 Cadillac.

9. Today's Main Street Station next to the old Guerneville Bank.

The fire of 1919 devastated the center of town.

"They was tried for arson," said my old friend. "Was because they was here a short time and had taken out the stock. They was tried before for arson of their other stores, one over in Wheatland, 'nother down by Lodi, 'nother in Napa."

The townsfolk laid on with everything available to put out the flames. The two carts were put to use; the chemical extinguisher was next to useless against such a big fire. The hose cart was connected to a hydrant. Men, women and older children manned the bucket brigade.

"Yup," said the rustic character, "it was probably the last bucket brigade to fight a fire in town. A lot of people wouldn't give ya ten cents for the whole town that night. Everybody worked hard," he chortled. "Noel Tunstall, the undertaker, was up on the roof with a hose an' his hair got singed an' someone threw him a hat. It finally got too hot fer 'im so he come down."

Since it was a hardware store, paints, oils and the like were present. Within fifteen minutes of the start of the fire, the heat exploded the front of the building with a rumble while paint and rubber products, along with ammunition, contributed their share to the excitement.

"I recollect as how there was an old phonograph playin', you know, a Victrola. It was playin' a right tolerable quick piece of music," said Ol'

Timer. "Can't remember what it was, probably 'A Hot Time in the Old Town Tonight,'" he chuckled.

Three homes burned that night along Third Street behind the store: Newton Lark's; to the east of him, Reverend Dain's; and next to the reverend's, W.D. Cannon's. The fire was put out by mid-morning.

Hocker and Cannon were charged with arson, and a preliminary examination was held.

"I testified at the examination in Santa Rosa in Judge Barnes's court along with nearly the whole town, but I wasn't called as a witness durin' the trial," Ol' Timer said.

My friend gazed down at his nearly empty coffee cup held in his gnarled hands. "Can't figure it out to this day—they was found not guilty."

OAKLAND NELL: GUERNEVILLE'S "BELLE OF THE NIGHT"

Sonoma County Historical Society Journal, *1990*

There is one subject in history about which it is difficult to find facts: sex or anything related to it. By perseverance, bits and scraps of information are slowly uncovered. The case of Guerneville is no different from any other small town, where everybody knew what was going on but nobody talked about it. The Victorian age still rules strong.

A faint picture of Guerneville's "ladies of the night," "painted ladies," "fallen women" or "soiled doves" emerged after conversations with many old-timers—men and women born around the turn of the twentieth century who lived most of their formative years in and about town.

The first "lady" madam definitely identified was Alice "Henny" Bee, known as "Old Lady Bee." In 1892, her occupation, or lack of any, was alluded to in the following message to Mr. J.W. Julliard, member of the board of supervisors. It also questions her qualification to receive welfare:

> *May 11, 1892*
> *J.W. Juilliard*
> *I think Mrs. Bee's allowings of $8.50 per month should be stopped for few months, she wont work and run around town and get fellows in trouble. She wont take any mine washing say she has no time. Please inquire.*
> *Yours truly,*
> *G. Dietz, P.M.*

Guerneville's "Belle of the Night," Oakland Nell, sits on her bed (her place of business), clothed for her portrait.

If you haven't figured out the spelling, it is because Gerhardt Dietz, the town's postmaster, was born and raised in Germany.

According to the old-timers, Old Lady Bee was short and heavy, known as the town gossip and never swore. She had one daughter described as a beautiful redhead, who later left town. Since Bee was "kind of destitute," the menfolk would "donate" firewood, boxes of produce, etc. to "help her out."

Another Guerneville girl was "Oakland Nell," real name unknown. She was conducting her social service from about 1905 to 1910, but it is unknown how long she remained in town. Again, information about a trollop in this small town is sparse. There is a strong possibility she worked in the "house" that still stands in Guerneville.

This hooker-house is across the street from the Chevron Station[10] on Main Street. The second-story rooms were typically "crib" size, approximately eight by eight feet. There were at least three of these "cells."

With the exception of the July rush of urban prostitutes to the river area, no painted woman was successful in this town. To quote one old-timer, "Why pay for it when you can get it free?"

10. Known today as Sonoma Nesting Company, directly next to the Guerneville Plaza.

Part IV

All Work and No Play

Olives along the Russian River

The Paper, *September 28–October 4, 1979*

The tourist is gone, autumn has arrived, school is in, grapes are ripe. It's time for another harvest. It wasn't too long ago that hops, in addition to grapes, were a major crop along the Russian River. There are some people today who harvest prunes and apples from the orchards that line our stream.

As I looked around for little stories and histories of our area, I spied a small row of olives trees east of Korbel Winery. After talking to Ol' Timer, I pieced together a story of one man introducing a cash crop to our environs.

It was 1889. Dr. Joseph Prosek, physician of San Francisco, came to visit his friends the Korbel brothers. He came upon the idea to grow olives near the Humming Bird Saloon, known today as Santa Nella in Pocket Canyon.

He cleared off about one hundred acres of redwood stumps and brush from the rolling hills and placed a huge wooden water tank on the highest hummock. Prosek and his hired hands worked laboriously installing a steam pump next to Pocket Creek that had a capacity to pump five thousand gallons an hour. They laid approximately eight miles of irrigation pipe throughout the young grove of olive trees. The trees were planted twenty feet apart.

The Santa Nella winery, originally the olive mill, taken in the 1970s.

The doctor chose the Picolines variety to grow first, not because the fruit was next to worthless but because the trees were rapid growers. In two years, they were six feet high. He used this stock to graft on Cenuduling, Colunella and Rubra varieties. The year 1894 was the first one that the trees produced a crop.

The budding botanist grew olives not for eating but for the oil they could produce. As a result, he squeezed out seventy-five gallons of oil of this first crop.

The following year, Prosek built an olive mill that had all the latest developments up to that year of '95. The building was forty by sixty feet and two stories high. The crushers worked on the same idea as a flourmill: the basin was granite, like the two 1,500-pound rollers. This equipment was made and patented in San Francisco in October 1894 and cost the doctor close to $1,000 (roughly $25,000 by today's currency). Besides the crushers, there were presses, agate ironware tanks, boilers, separators, drawing cans, etc. The power for this little industrial complex was supplied by a twelve-horsepower engine. The enterprise was known as the Sonoma County Pioneer Olive Mill.

Dr. Prosek was quoted as saying, "It makes me sigh when I start in to figure up the cost. But I have every confidence in the outcome and think we shall surely be repaid in the end of our outlay."

The season of '95 produced thirty tons of olives. To supplement this, Prosek sent out his brother to purchase all the olives available in the county. One Captain Grosse of Santa Rosa sold fifteen to twenty tons to him at sixty dollars a ton. The olives produced forty gallons of oil per ton depending on the variety. Production started mid-December and continued into March as each variety ripened.

And so it went year after year through the Gay Nineties and into the twentieth century. It was about 1905, after several lean years, that Prosek pulled up his beloved olive grove and, like his friends, planted grapes. The grapes prospered and helped establish the name Santa Nella Winery.

Dr. Joseph Prosek died about 1919, but several buildings—the winery and, across the canyon, his home—still stand as mute reminders of a pioneering spirit.

When Tobacco Farms Thrived in Guerneville

Sonoma County Historical Society Journal, 1992

California is not known to be a state where tobacco is grown for commercial purposes, but occasionally an enterprising person would attempt to do so and meet with some minor success. During the Great Depression of the 1930s, a cigarette company was formed in Stockton and managed to produce a maximum of 500,000 cigarettes a day (2,500 cartons) from California-grown tobacco. In Napa and Sonoma Counties, there were areas that the California Department of Agriculture thought might produce some average-grade tobacco on a small scale such as upper Napa Valley and Alexander Valley.

In 1903, the Hermitage Tobacco Company of Cloverdale had some extensive acreage under tobacco.

The start of Guerneville's tobacco story began about two miles above the quicksilver mines. In 1877, David Hetzel arrived and started planting on the western slopes of Mount Jackson. About a year later, he was joined by Charles Schuler, and together they produced an acceptable leaf resulting in a salable cigar. The first public mention of this was copy in a Santa Rosa newspaper: "They plant and cultivate their own tobacco, of good quality, cure it and manufacture it into cigars."

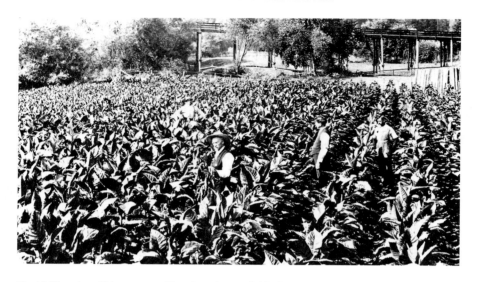

David Hetzel and his crew working the tobacco fields. Note the posts of the Guerneville Bridge in the background.

About the end of March 1880, they moved from the hills to Main Street (today's First Street) in Guerneville. They rented a piece of land along the river and cultivated ten acres of tobacco. Two years passed, and then the two men dissolved their partnership; supposedly each was to continue manufacturing cigars, but in truth only Hetzel continued the trade. Sometime between 1882 and 1884, Schuler left Guerneville for Petaluma.

In 1904, Hetzel was awarded a silver medal. The whole thing came as a surprise to him, as his tobacco had been entered for competition unknown to him.

This is how it occurred. Adam Wolfrom, a cigar maker of San Francisco who was going to visit his old home in St. Louis, procured from Mr. Hetzel a few samples of his tobacco to show his friends there to what degree of perfection our townsman had attained in growing and curing the weed. Arriving in St. Louis and its World's Fair, Wolfrom went to the Agriculture Building looking for the Sonoma County display—but there wasn't any! He was sent by Judge J.H. Wills of the Sacramento Valley Association to Solano County's booth, the county nearest Sonoma having an exhibit. There, C.W. Becker of Solano took the migrant leaves, by now losing some of their quality, and displayed them with a sign saying "From Sonoma County."

The intention was for them to be ornamental only, but Becker entered them for a medal anyway. It was just in time, for the awards were soon made, David Hetzel among them. Hetzel heard nothing more of Wolfrom until the

following letter reached him and he discovered that his friend had entered his tobacco for competition at the exposition. The letter in full was printed in Guerneville's local paper, the *Russian River Advertiser*:

> DAVID HETZEL, SR.
> AWARDED SILVER MEDAL
> LOUISIANA PURCHASE EXPOSITION, CALIFORNIA
> County Commissioners Association.
>
> *St. Louis, Oct. 17, 1904*
> *Mr. D. Hetzel.*
> *Guerneville, California*
> *Dear Sir:*
> *Yours of Oct. 8ᵗʰ received; also a box of cigars. I have passed them around to people who are interested and they all pronounce them fine.*
> *You were awarded a silver medal on your tobacco and I had no doubt you might have received a gold medal had it been exhibited on time and in the proper manner.*
> *Yours truly,*
> *C. W. Becker*

The following year, Hetzel made a concerted effort and entered competition with his tobacco in the Lewis and Clark Exposition at Portland, Oregon. Again he was awarded a diploma and a silver medal.

Now Washington, D.C., was interested in this surprising horticulturist. In March 1905, the U.S. Department of Agriculture queried Hetzel if there was a practical and profitable way to grow tobacco in California. His answer paraphrased was:

> *Use the Havana variety in a rich sandy loam. The advantage of this soil is that it retains moisture and is easy to cultivate. Alkaline soil would be fatal in my estimation as the plants seem to absorb this chemical and destroy the flavor and injure the burning qualities of cured "leaf." If carefully worked with and cultivated thoroughly, an acre can produce 9000 plants.*

As Jack Hetzel, his son, said, "The seed-pod blossom of the numerous tobacco fields gave an aurora of beauty against the green garden of mighty wavering redwoods."

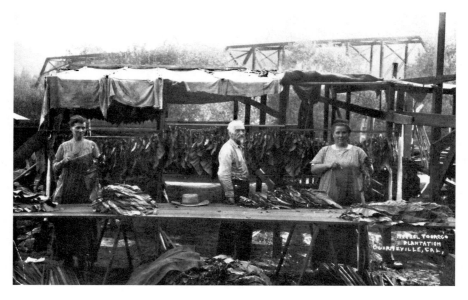

David Hetzel, joined by Nellie Justis (left) and Nell Morrow (right), curing and preparing the tobacco leaves.

Dave shelled his own seeds from pods, sowed them in his nursery beds and then transplanted them in his fields. This was done as late as mid-July, when the plants were six to eight inches tall. The crop was harvested sometime early in October. For the most part, Hetzel did not irrigate his fields before or after transplanting. Two crops may have been grown; the second, known as a sucker crop, grew from the stalk after the first crop had been cut.

Until 1904, Hetzel used Sumatra leaf wrappers, but rains for that season were the right amount, so half of his crop of Havana was first class for wrappers and he didn't import any for the coming year. It was probably this leaf that won Hetzel the silver medals.

His curing shed for all his tobaccos was George Guerne's hop house located just up from today's Brookside Resort.[11] His fields were located variously at Armstrong's on the Mines Road (now Armstrong Woods Park Road), El Bonita (halfway between Rio Nido and Guerneville), Northwood, Forestville and on Guerne's land near the hop house (a vineyard today north of Surrey Inn).[12]

11. Known today as the West Sonoma Inn and Spa.
12. Known today as the Sonoma County Transit Park N Ride.

Hetzel had various people assist him in producing his crops and product. Fred Ewing was generally his right hand man. Besides his sons, David J. and Jack, there were Ben Drake and Rudolph Brown working the fields; at the curing shed were Nell Morrow and Nellie Justis. Others were hired to help the tobaccoist make cigars. Usually there was only one, but on occasion two were in his shop, consisting of George Gibson, Rudolph Brown, Edward Nee, Michael Dunn and Harry Schloke. Brown worked for him for several years.

One of the earliest labels of Hetzel's cigars was La Dulzura de Albuerney Menendez. This brand was probably made before the turn of the century. Later, cigars were sold under some five different labels. The Cabella Flora sold for five cents, and the Henry Clay was a cheap saloon cigar. El Resorto was a ten-center that Hetzel sold only at this store, and Hetzel's Best went for twenty-five cents.

Hetzel continued off and on after 1915 growing tobacco and making cigars. He finally ceased due to his age. He passed away at the age of ninety-five in 1935.

MINING TRAGEDIES AT MERCURY'S MINE

The Paper, *October 2–8, 1981*

I was standing in the bank waiting my turn and nodding hello to friends who were also banking.

"Hi, Bill," I said. It was Bill Vogel.

"Hi, John," he returned. "I sure liked your last story with Frank Genoli and Ol' Timer."

"Thanks. Digging up anecdotes about the river area like that one about the Roaring Lion mine is fun when it comes from our town characters."

"Sure it's fun," he responded. "You know the mines have a lot of stories. Some of them are pretty gory."

This was an obvious hint that here was a story.

"When you get done here, hop across the street for a cup of coffee."

"Fine," he said.

I had just plunked down in a booth at Pat's when Ol' Timer swaggered through the door.

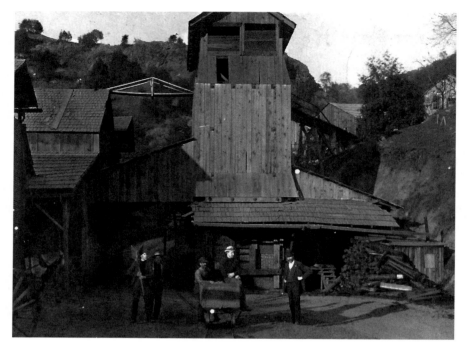

Workers at the Mount Jackson Quicksilver Company mine, taken at the turn of the century.

"Hello, Ol' Timer."

"Howdy, Youngster. Mind if I join ya?"

"Sit yourself down," I said. "Bill Vogel is joining us. I ran into him at the bank and we got to talking about the mines."

I ordered three coffees from Karen Chambers just as Bill walked in.

"Hello, [Ol' Timer]," greeted Bill. He used Ol' Timer's real name.

"Howdy, Bill. Haven't seen ya too often since th' mine shud down."

"Yeah," said Bill. "Probably just as well I did leave then. The place is real unsafe—lots of methane gas, rotten timbers, collapsed tunnels. It's pretty near filled with water."

"I didn't think this mine had gas in it," I responded.

"Sure there is," answered Bill. "Back in 1960 to '61, two men were down there and went over to some old workings to have a smoke, or so I heard. The chamber just exploded. One didn't have a shirt on—it just burned all the exposed skin—chest, fingers, eyelids. He looked horrible. The other one had his sleeves rolled up so his face and arms got burned. Doc Ellison took care of them for months."

"There was one worser 'en thet," spoke Ol' Timer. "Had more miners burned."

"Oh, really?" asked Bill.

"Yeh, it was back in 19 and '4, 'bout November. They was four of 'em down on th' 600 level ta blow out gas pockets or some such."

"When I left the mine," Bill broke in, "we were down to the 1,450-foot level."

"Anyway," continued Ol' Timer, "there was an explosion—killed one ou' right. Two others were burned bad. Fred Sicotte, he's th' one what tol' me about it, got burned a little bit. He sed he laid down an' covered his face. He finally got up and foun' his coat afire—so's his hat. Well, he chucked 'em an' made fer the shaft, but he coultn' breathe cuz all the air's burned."

"Gads, what a predicament to be in," I said.

"Yep. He cud hear moans and groans in the dark, so he made his way to the main shaft ta get help. He had ta climb up ta th' next level, a hunert an' fifty feet, ta signal th' lift operator.

"Well, the doctors was called from town, Byron an' Cole, and they did what they could ta help th' survivors."

"Did anymore die?" I asked.

"Yep. One of th' survivors down in th' city. Come ta think of it, Sicotte tol' me he was in another blowup in th' mine some years before this 'un. One man died in thet one, and another hurt."

"Sonofagun," said Bill. "I wonder how many have been killed up in there? I remember one that was killed when he was crushed, a young guy."

"Well, le's see." Ol' Timer squinted his eyes up at the ceiling in thought. "I don't know of any afore Sicotte's first 'un, so I can give three. Bill's one makes it four. Do you know of some, Youngster?"

"No," I said. But after a second thought, "Yes, there were three killed in the '06 earthquake, not really a mine accident. A boulder was shook loose from above the mine shaft as the skip was coming up, the rock went down the shaft, killing the three. I've got their names at home."

"They make seven we come up with then," concluded Ol' Timer.

"Well, I'm going home and find those names so I can get a story out," I said. (The names were Robert Gorsky, Charlie Hanson and Fred Miller.)

"Okay, Youngster."

"I'm going too, John. See you later, [Ol' Timer]," said Bill using his true name.

"Ya take care, Bill."

As Bill and I went out, he said, "That old guy sure has a good memory."

"You've got that right, Bill. See you in *The Paper*."

THE GHOST OF MINES PAST

The Paper, *December 25–31, 1981*

"Howdy, Youngster."

"Howdy to you, Ol' Timer."

We were in the hardware store looking over axes, wedges, splitting mauls and the like.

"Yer las' story 'bout the mines tickled my memory, so I poked around home an' come across some ole news articles Pa saved. They was about a mine up the Austin." He rambled on. "It had a ghost hanging aroun' it."

Ole whisker-face shoved some yellowed newsprint into my hand. They were cut from Healdsburg and Santa Rosa papers.

"I think ya kin get a good story out a those." He pointed a gnarled and scarred finger at the clippings.

I quickly glanced over the columns and saw his story.

"Thanks, Ol' Timer. I'll hop on this right away and get it in *The Paper*."

"Go right ahead, Youngster, see ya 'round," and he waved as he shuffled out the door.

In 1875, the Croesus Mine was located about three miles west of Guerneville on Austin Creek watershed. Several men were employed there, supposedly looking for quicksilver, when "a real ghost" appeared. The ghost poked around the surface works from time to time. The surface works were made up of the blacksmith shop, with bellows, forge and anvil, a bunkhouse for the hired hands and other sheds.

The men worked two shifts for a while, a day crew and a night gang that worked from 10:00 p.m. to 3:00 a.m. After the night shift was discontinued, someone or something was making commotion like a regular shift was working. Sounds of bellows blowing, drills sharpening, windlass winding— general noise—were heard from 10:00 p.m. to 3:00 a.m. But with all the noise, no work was done. Everything was in the place where it had been left the day before.

The bunkhouse was a little distance from the mine shaft. Whispers had been heard there by the men. The door would open a little as if someone was going to ask a question and, after getting an answer, would withdraw.

Upon seeing the ghost for the first time, the men were so terrified "as if to flee for dear life." Some had courage enough to go back and talk to the apparition. "He" answered some questions but asked none. The description

by the miners to the papers was one of a well-built strong man, weighing about 180 pounds, middle-aged with a fair complexion (pretty solid evidence to be a ghost).

The noisy work continued for three nights in a row. Then all was quiet for three weeks.

One issue of the *Sonoma Democrat* prints: "The Citizens in and around Guerneville cannot account for the strange freaks of this unwelcomed intruder. Several well known citizens have been there and offer to prove to any skeptic the reliability of the statements."

Abe Starrett was working alone in the shaft; the other men were above ground. He was preparing to place a dynamite charge when he heard a noise behind him. He looked, and there stood a man dressed as a miner where nothing had been standing an instant before.

Starrett asked, "What do you want?"

No answer.

Abe punched at the figure with a drill. It passed through the "airy semblance of humanity."

Starrett whistled to the men above to come down.

He then said to the form, "Or if you want me to work here you must get out."

Whereupon the misty miner seemed to vanish upward from sight and has not been seen since.

Jenner Jetty Lost to Peaceful Pacific

The Paper, *April 25–May 1, 1980*

I was out at River's End viewing the coast on a crisp spring afternoon with my sons. One boy noticed some pilings and steel rails on the opposite shore of the river. He asked me what they were for, how long they had been there, things like that. I didn't know, but I knew who would.

Next day, I was eating my usual Danish and drinking my usual coffee at Pat's Café when Ol' Timer trundled through the front door in mackinaw (unbuttoned) and knit cap with gray hair squirting out from underneath it.

"Mornin', Youngster."

"Hi, Ol' Timer," I replied. "I've been waiting for you—I've got a question about the jetty at Jenner."

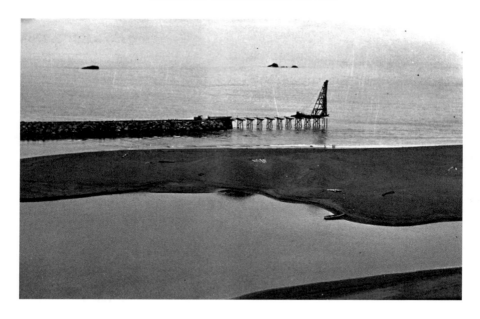

The Jenner Jetty, near completion, sits idle against the gray background of the fog in this 1934 photo.

"I don't know much about that thing," he stated. "Ya ought to ask Tom King Sr. He worked out there back in '29. He be the one ta talk to."

A couple days later, I got the story from Tom King and the role he played.

The project was to build a jetty across the mouth of the Russian River and make its entrance along the north short to the ocean. This would provide a better entrance for barges and boats to cross over the sandbar. It was planned that gravel and sand, which didn't have to be segregated because it occurred naturally, would be hauled down to San Francisco for use at the Golden Gate Bridge and the Bay Bridge.

The work at the proposed jetty began in May 1929 when the major contractors, Healy & Tibbots, drove pilings and laid rails to block the old mouth of the river. The project was sponsored by Russian River Gravel Company, but when the money ran out at Christmastime, the state took over.

The two locomotives used to pull the two flat and three dump cars were four-cylinder Plymouth mine engines. These little powerhouses came from San Francisco, having just finished working on the Twin Peaks Tunnel. Tom King ran one, and Jim Antone from Steward's Point ran the other.

To get rock and fill, the crew of some ten to twelve men tunneled into Goat Rock about sixty feet and then worked to the left forty feet and to

A worker sits atop a massive boulder as they work to transport it from the face of Goat Rock to the Jetty construction site, taken in 1931. Note the locomotive at the left of the photo, used in the Twin Peaks tunnel construction.

the right sixty feet. Basins were carved out of the floor of this cross tunnel, each about two feet deep and four feet across. There were five of these basins in the cross tunnel, each filled with three hundred pounds of black powder and spiked with twenty-five pounds of 40 percent dynamite. As each basin was loaded, the tunnel was backfilled with the rock blown out to make the tunnel.

The sixty-foot entrance tunnel was treated the same way; it had three basins loaded with explosives and backfilled with rock. The dynamite acted as a breaker, and the black powder, because it burned slower, was the lifter of the fractured rock. When the works was detonated, the east face of Goat Rock was to be made a rock and gravel pile.

Everybody from the surrounding countryside came out to watch the whole rock go up in dust. Cars were so packed up on the bluff opposite Goat Rock that none could turn around. The shot was perfect. The face of Goat Rock just heaved up at the time of the explosion and settled back.

One person said, "I can belch louder than that."

The crowd left disappointed.

The crew worked for four years. They would sometimes dump a rock weighing ten tons or better on the ocean side of the railroad tracks one day and find it on the opposite side the following day. This would happen during

October, when storm waves rolled in and the crew was still working. The job was shut down during the winter.

In the spring every year, winter damage to the jetty had to be repaired before continuing work. Wooden piles finally replaced steel I beams because they were twisted all out of shape.

When a large rock was lifted onto a flat car, it would swing around, untwisting the steel cable, and then it would reverse itself. This weakened the cable and splices. Jack Shell kept working full time making chokers and slices.

The day Franklin D. Roosevelt took office, March 5, 1933, the job shut down. It didn't reopen until 1941. That's when Basalt Company took over the contract and poured cement on the jetty.

FLOOD OF '79 SANK STUMPTOWN

The Paper, *January 18–24, 1980*

I was sitting at Pat's nursing a cup of java at the counter, watching faint images in the fogged-over mirror. Humidity from the rain-soaked clothes hung heavy in the air. The café was packed.

Conversations about the rain and the river rising drowned out the storm drumming on the roof. They talked of the rate of rise, inches of rain and crests of the biggest floods. I waited for Ol' Timer to make his usual appearance so I could pump him for facts about floods in days past; he was a no-show, so I had to go it alone. Outside of Ol' Timer, the best source was the newspapers.

The first of the recorded big floods was just over one hundred years ago. The rain started in mid-February 1879 and continued moderately for over a week. The ground was saturated. There was a little runoff, and the river was fordable. A storm arrived on March 3, pounding Northern California. The river began to rise a foot an hour that Tuesday and continued until Thursday morning, when it crested at forty-two feet above summer level.

Damage was widespread. The track of the San Francisco & Northern Pacific Railroad was submerged nearly its whole length along the Russian River. Damage to Korbel's Mill and its properties was in excess of $7,000; its boilers and engines were submerged. Closer to Guerneville, the ground slid out from under the railroad for over one hundred feet and dropped into the stream, leaving the track dangling.

Havoc occurred in town. Water was backed up in the creeks and low areas north of the village, rising until the whole town was inundated, with the exception of the south side of First Street along the surging stream.

Twenty-two families were driven from their homes. The houses were mostly one story; some had water to the ceilings. Those living in two-story dwellings were taken by boat from the upper floor to Taggart's Hotel or the Good Templar's Hall on First Street. The church, post office and a few high homes were used as havens by the thankful refugees. Some eighteen houses were either afloat or off their foundations. Two homes were washed away by the caving of the riverbank, but the contents had been removed beforehand. Another floated off some distance and settled down on a hillside. The working men's cabins, built near Heald & Guerne's Mill, floated up to Murphy's mill a mile away near today's Laughlin-Watson Roads area. Jim Taggart's barn joined them going up to Murphy's, sailing around there and finally returned, settling near its original site. Fences were carried off with sheds and outhouses.

Heald & Guerne was hard hit. Part of the mill fell into Fife Creek because of soil erosion. The two-story moulding shop nearby did the same but was saved by

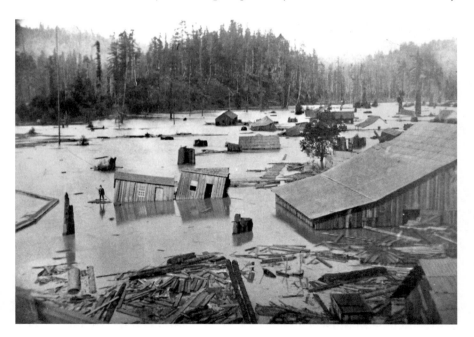

High water, 1879. The strength of the Russian River could relocate the largest of structures with ease. Note the man standing on a platform, center.

literally tying it to some neighboring stumps. The lumberyard was a mess. Board piles were lifted up and scattered in all directions, some lost to the river. By the end of the flood, none was left standing.

The chair factory was lifted up and carried out into Fife Creek, but it came back wrecked. The warehouse containing several hundred chairs was broken up and its innards scattered.

The woodchoppers were heavy losers as a great deal of cordwood was swept away. There was great danger in the woods, as large limbs were blown down. The air on Wednesday (during the middle of the storm) was filled with the sounds of crashing forest giants tumbling from the riverbanks. On striking the water, they would splash the yellow floodwater close to one hundred feet high. After the flood subsided, runoff loosened soil, and the sound of trees falling could be heard for days. Danger was presented to anyone who ventured into the canyons.

The town spent three weeks cleaning and repairing the damage. Fences were reset; barns and sheds righted; driftwood, trash and mud were cleaned from house and lot alike. Heald & Guerne's workforce took pump and hose, washed and repiled lumber, salvaged and repaired machinery.

Finally, the train arrived. It was welcomed with a salute from the mill whistle—the locomotive returned the same.

All damages were repaired, and the town returned to norm.

Snow and Ice

Yesterday & Yesteryear, *December 2011*

The snow would fall mostly at night and last a few hours or from three to four days. One thing about snowfall is how quiet it is. Quiet, not like rain and storms. Quiet because it muffles the sounds of highway and town. To stand on a street, watching the weather falling and no sound. To stand out in the weather and not get soaked.

"Back in the old days"—the 1870s—it wasn't all about snow but freezing temperatures. We are talking about cold spells—plural. The cold would arrive anytime from December to as late as April. Ellen Bagley, Guerneville correspondent to Healdsburg newspapers, wrote on April 6, 1875, "Ice is ½ inch in thickness and yesterday a snow storm."

Winter in Monte Rio, circa 1930, with houses and resorts along the river. This photo shows the cold and crisp beauty of a now rare scene along the Russian River. Such views during the late 1800s occurred about every three or four years.

Three years later, on December 23, 1878, she wrote, "Cold weather continues…Ice has formed on small ponds in the river, out of the current, two and half inches thick. A pair of ice skates has been procured and the young amuse themselves by skating on genuine ice."

The following winter of 1879, she wrote to the papers of an amazing story. The reader must take into account that the countryside was still covered with redwood forest, the few towns hard by the river and roads were mud. The air hung heavy from low gray overcast mixed with smoke from homes and lumber mills:

> *The cold weather still continues. The thermometer has marked 22 above zero, the lowest ever recorded here. The river is scarcely higher than in the summer, and the foot bridges are all in place. The young people have been enjoying rare sport in skating. A party went down the river in a boat to an ice pond about three miles below here and held a picnic. On their way down they had to break ice before them, which had formed clear across the river about ½ inch thick. The pond was 160 yards long and 58 feet wide. After skating a while they had lunch and then more skating.*
>
> *After skating a hole was cut in the ice, which exactly measured 4 inches thick and very pure and clear.*

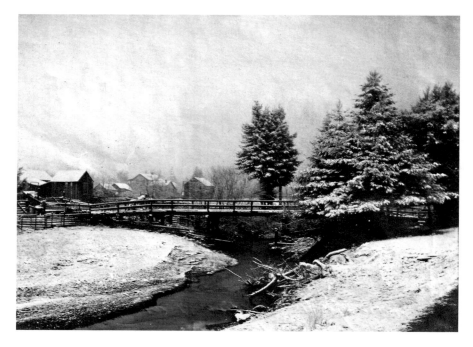

Snow along Fife Creek, looking south toward town.

> *A week later, went down again this time in a wagon, and enjoyed another day's sport on the same pond. The ice was thinner and threatened to break under their feet. A small wood sled was used to give the ladies a ride.*

Two weeks later, Ellen again wrote:

> *The protracted cold and its severity, has given rise to an enterprise new and novel to this section of the country, that of ice packing. The "Russian River Ice Company" has been formed with Chas. S. Middleton as president; a suitable warehouse prepared, and several tons of ice carefully laid away for use in the coming summer. As it is a new business to most of the company, the experiment may be a failure, but a generous public are wishing for them the success they deserve in making the trial.*

This was the first and only ice company in Sonoma County to have ice made by nature and not by mechanical means.

Mount Jackson had snow intermittently over the next four years: March 1880, February and March 1882. In December 1882, the river towns had

snow up to three inches deep. Two years later, Jackson had snow again. In 1890, it snowed January 2, 29 and February 26. In 1906, a storm dumped a foot of snow in west county.

The difference in frequency of snowfall compared to a century ago or more is obvious. Snow came every other year and usually more than once a winter; it now falls maybe once in a decade and only once that winter. Snow varied in depth in the canyon bottoms, from just a dusting to as much as four inches, as was reported on January 1, 1916, and the same for January 15, 1932.

Though there were occasionally intervening snows, forty-two years passed until the recordbreaking "white blanket" fell on January 3, 1974. Downtown Cazadero received eight to ten inches, while Monte Rio and Guerneville got five inches. It was estimated that two feet and more fell on the surrounding hills above Cazadero. It was cold enough that snow even whitened the sand dunes at the coast. More snow fell on January 4.

The storms wreaked havoc on west Sonoma County. Redwood trees, as well as oak and bay, were knocked down, taking with them power and telephone lines, blocking roads and state highways. Pocket Canyon and Bohemian Highways, Seaview and Fort Ross Roads, various locations along Highway 1 and lesser roads were closed. The trees were not selective; they also fell on cars and homes.

People and families were stranded if not isolated in the rural countryside because of the snow depth and downed trees. Sheriff Don Striepeke ordered deputies to remain at the Guerneville substation to answer specific calls for assistance and emergencies rather than go out on patrol.

Nearly everyone who had a chain saw was out cutting up the trees, helping the state and county road crews clear roads near their homes and in the surrounding neighborhoods and also conveniently setting in next year's supply of firewood. The old-timers who had experienced power outages, usually every year, fired up their Coleman lanterns, kerosene lamps, wood stoves and generators. The newcomers were concerned about cooking on wood and kerosene stoves. In Cazadero, a group was formed of those who had generators. They went around to homes that had no power and supplied electricity for a period of time so foodstuffs in refrigerators and freezers would not be lost.

It was close to a week before everything was back to normal and power was restored to about 90 percent of the people. Chain saws would growl through the balance of the winter and into the spring.

Thus, another snowstorm entered the record book, but this one went to the top of the list.

Part V

THE ROOTS OF OUR PAST

A CHINESE NAMED MAHONEY

The Paper, *July 23–29, 1982*

It seemed hot at seventy-five degrees, compared to the late winter weather we had here. I was in Pat's Café sipping iced tea when Ol' Timer shuffled in from the midafternoon warmth.

I knew now winter was over; he had shucked his mackinaw for spring and summer. But he hadn't given up his knit cap. White hair squirted out from under it.

As my friend came toward me, I could see his white four-day-old beard. I swear he never shaves, but his beard is no longer than a four-day growth. There it sits on his face day after day the same length, adding to his character.

"Afternoon, Youngster." He plunked down in the booth opposite me. "Whatcha starin' at?"

"Hi, Ol' Timer. I was just thinking what a town character you are."

"Humph. I dunno whether ta take thet as a compliment er not," he said, smiling. "Yeah, I guess I am one, carryin' on like I do. But ya know sum of it's just fer show."

His bushy eyebrows twitched with malicious mirth.

"Karen," he called the waitress, "could ya get me a iced tea like the Youngster here?"

He continued, "This town's had more 'er its share a characters."

"Yes, I remember a few like MacPherson, the street sweeper, and Freddy 'Beep-Beep' Jason, both long gone now."

"Aw, they was nuthin' compared ta Dirty Frank, an' Tom Cat—never did know his real name—an' Alabam and not fergettin' the wimmen—Kansas City Kitty!"

We both started chortling.

"Do you remember Gordon Selwood? He lived at Greystone. He always used to say he hung up his clothes on the floor. And then there was Sweet Pete. He was a handyman and was hired by Alice Blue one time. He scared the feathers off her when she came home one evening. She walked into her bathroom and there he was, sitting on the throne deader than a doornail."

"Yeah, betcha she twern't blue for a while, mos' likely ghost-white."

"Poor pun, poor pun," I said, chuckling with him.

"Well, I'll try ta do better nex' time."

"I just happened to think—most of the town characters have nicknames, and nine times out of ten the character is a man."

"Yep, back in muh childhood days alotta muh frens had nicknames. They was 'Cap' Trine, 'Buster' Clar, 'Piggee' Pells, 'Jarweed' Johnson from Forestville an' one little gal 'Pet' Belden."

"I remember, Ol' Timer, while I was doing my research on Russian River history, I came across a couple of articles about a Chinese gentleman in town. I could never find his real name, only his nickname given him by the men about the area—Jim Mahoney."

"I pity thet pore cuss being saddled wit a moniker like thet."

We chuckled because Ol' Timer's heritage was Irish in part.

"Do you know or have you heard of this Jim Mahoney?"

"Nope, can't say iffen I had er not."

"Well, now it's my turn to tell you some history."

"I'm always open fer a story 'bout our little burg."

So I spun my historical anecdote for Ol' Timer:

It was back in 1886 during the movement throughout the country to send all Chinese—native born, naturalized immigrant and alien—back to China. There were race riots and similar civil outbursts throughout the West.

Guerneville, Duncans Mills, Occidental and the lumber mills had Chinese living in or near them. Guerneville, like the rest of the white population at large, showed its racial prejudice by hanging up posters saying "The Chinese must go!" The residents ran the Chinese out of town with the exception of one—Jim Mahoney.

An etching depicting Chinese workers laboring over the Russian River Railway. Taken from *Frank Leslie's Illustrated Newspaper*, November 23, 1878.

In the small town of Guerneville, Jim Mahoney was a well-known "landmark." It was probably because he was so well known that he was given an extra week to get his personal affairs in order before he would be forced to leave town like his countrymen. That was all the time he needed.

Mahoney used the week to learn and adopt more habits, customs and clothing style of the general population. He was already fond of playing poker and liked a "two-finger" glass of whiskey. To remove any doubt from the people's minds, he bought a silk hat and cut off his queue—the long single braid of hair that was a dominant part of Chinese life.

He successfully switched lifestyles from oriental to occidental. It wasn't so much fear that caused his switch but where his security, amenities and friends were found. Obviously, along with his name he became the butt of friendly jokes, but the men about town liked him, gambling and drinking like the rest of them. He was protected from undue harassment and treated justly.

On one occasion, though, two Italians beat him unmercifully. The attack was unprovoked. Two days after the assault, a jury trial was held in town. The jury reached a verdict of guilty. The judge sentenced them each $100 or one hundred days in jail. They paid the fine.

Nobody bothered him; he was the town's mascot and only Chinese in town. One person wrote to the *Russian River Flag* in Healdsburg: "Our solitary Chinaman, Jim Mahoney, is learning to write English. He is born adept at gambling and irrigates fluently."

It was right here in my story that Ol' Timer interrupted me.

"Irrigates fluently? I've heerd a some off-ball characters in muh life but din't hear of no person irrigatin' fluently—sounds downright nasty. What happened to 'im after thet?"

"Well, Mahoney had 'gone native.' He stayed around about seven months, maybe longer, before he got lost in the mists of history, probably irrigating fluently."

We both chuckled at our private thoughts about it.

"Well, I've got to be going, Ol' Timer, and get this story into *The Paper*. Oh, by the way—welcome to summer."

"You too, Youngster."

THE HOUSE ON THE HILL

Excerpt from Guerneville Early Days

There is a house up in Highland Park overlooking Guerneville now covered by trees and hidden from view by tall hedges. It wasn't always like this. When it was built in 1881 on Nob Hill, it had one of the grandest views along the Russian River. It was for many years one of the more stately homes around and a prominent landmark with only a single big redwood as its neighbor. This residence was built by a passing enterprising young man, John French.

French was born in Maine in 1851. His people were farmers, self-sufficient, with Yankee ingenuity. He worked in the woods for his dad, getting firewood and making logs. By the time he was twenty, he had gone to Michigan and worked as a cruiser in the woods, returned home, owned 1/20 of a large slate quarry and started a candy shop.

John was twenty-five when he sold the confectionary store and came west to California. He wasn't in San Francisco long before his money played out. He headed north to the timber camps of Sonoma County. Those were hard times that year—1876—in the woods. He met men coming out who told

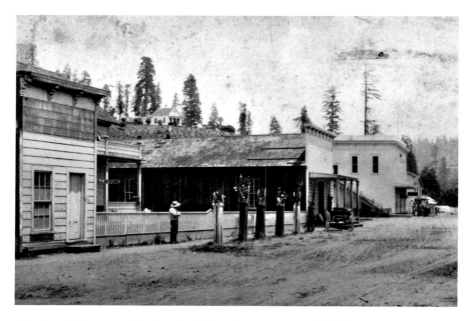

The French House, positioned on the hill just above town, overlooks Olde Town Guerneville, taken in 1886.

him to turn around. But as John, in his own words, said, "I never turn back when I start for anything."

In May 1876, he started to work for a logging contractor at Duncans Mills for thirty dollars a month with board. Two weeks later, he was offered by a mill owner sixty-five dollars a month and board. French took it and stayed with it for three months. He literally worked from sunrise to sunset. His new boss was a gambling man and eventually was in need of coin. His new offer to French was the whole lumbering operation, and again French accepted. By fall, the hardworking Yankee owned it all.

The following year, John came up to Guerneville and worked on a two-year logging contract with Heald & Guerne, the big mill in town. The New Englander saved a few thousand dollars and, with a Mr. McFadyen, in 1880 built a mill where Pocket and May's Canyons come together. The firm suffered damage during the winter of 1880–81 when the creeks rose and floated the mill off its foundations. No sooner had French and friend McFadyen done repairs than a fire broke out a month later and they, with no insurance, were without a mill.

John told McFadyen to rebuild and he would log again for Guerne besides supplying piles to the Guerneville & Fulton Railroad. The plan was a success.

John made enough capital to rebuild, pay wages and keep McFadyen and him in bacon and beans. The mill was back in full operation in six weeks.

It was during this time that the young man from Maine was smitten by a young Guerneville woman. Mary Etta Folks was the daughter of John Folks, successful owner of Folks Hotel in town. On September 14, 1880, Etta and John were married. Six months later, he built his wife the home on Nob Hill.

In 1883, John sold his share of the mill to his bookkeeper and went into the mercantile business. In five months, he built up a good patronage and sold out to Starrett and Glidden on recommendation of Colonel J.B. Armstrong. Like many businessmen of the time, French went to work for Armstrong on a handshake and no money mentioned. Two months passed. Armstrong asked him what he thought he had earned, and French answered, "Whatever you think is fair." The colonel paid him $2,000.

John promptly invested the money in one hundred acres of timber and bought Lundsford's old shingle mill on the edge of town. By 1885, the one hundred acres had been cut over, and the mill was moved to Big Flat Station near Duncans Mills.

The man ran his mill there, but true to form, he was not a one-job-man. This same year of '85, he constructed a two-story hotel and hall in Guerneville on the corner of First and Church Streets that, naturally, was run at a profit.

In 1889, the timber was cut out, and he looked for greener fields. He sold his mill, hotel and the Nob Hill home and moved to Humboldt County. He remained there until his death about 1920.

The French residence was sold to Hilton Ansell, a local attorney, and then the Clars (of Mays Canyon) lived there. The next owners were the Westovers (last owners of the Guerne mill) and then, lastly, the current owners, the Laws.[13]

The old French home, now 130 years old, has changed little, with the old big tree still looking down. Only the neighborhood has changed and the view is gone.

13. Ownership has since changed hands numerous times since the death of Harold Laws in the early 1980s.

GUERNEVILLE JUNIOR HIGH SCHOOL

Excerpt from Guerneville Early Days

The first week of September marks the end of summer vacation and the beginning of school. Some pupils will be in elementary grades and others in high school.

During the Roaring Twenties, Guerneville could boast of a junior high school for the town's students. The old grammar school was a two-room redwood structure built in 1882. After one year's use, it was found to be too small, and an annex was built. After some forty years of use with a slow but increasing student population, the need for a new one or a junior high school to relieve overcrowding was the solution.

Three women—Inza Lambert, Margaret Laughlin and Mary Wescott—gathered enough signatures of the local citizenry on a petition for a junior high school to be able to institute one for the fall semester in 1922. While the junior high school was in existence, the old school at the corner of Church and First Streets was torn down and a new one was constructed. This new building of 1923, however, is the Veterans' Memorial Hall we know today.

The junior high school was located at Pell's Resort on the west side of Mill Street just north of Main Street. Today it is called Riviera Resort.[14] The classrooms were in the dining room and kitchen. The dining room was divided with folding doors to make two classrooms; the kitchen made the third classroom. A woodshop was located in an old garage just north of the main building.

The first members of the school personnel were Mr. L.D. McKinley, vice-principal (the principal is unknown), and teachers Miss McElroy, Miss Kane, Mrs. Jensen and Mr. Pressley. Mr. McKinley remained until the end of the spring semester in 1925. Besides being the administrator, he also taught mathematics, geography, woodshop and physical education, all for a yearly salary of $2,500.

By 1924, the staff had been reduced to two teachers: Miss McDonald, who taught English, history, cooking, sewing and physical education, and Miss Gladys Leavell, who took care of Spanish, stenography and typing. Since they were staff and not administration, their annual wages were $1,700.

14. Now the New Dynamic Inn.

Schoolchildren lined up outside the Guerneville Junior High School building for their annual group photo, taken in 1923. The man at the top, center, is Mr. McKinley, schoolteacher.

The school year of 1925–26 saw changes for the forty-seven students at the junior high. There were all new faces in school personnel. Mr. Andrew Hastings, hired as principal, taught English, social and general sciences, shop and physical education. Among the new teachers were Miss Nettie Klabunde, who dispensed social science and mathematics, and Mrs. Vivian Beck, teacher of Spanish, art, typing, home economics and physical education. Mr. Hastings received $2,400 that year, Miss Klabunde $1,800 for two subjects and Mrs. Beck, for all her work in five classes, was salaried $1,680. Her classroom also happened to be the kitchen (what better place to teach home economics) with one sewing machine and seven typewriters.

The students had their extra activities besides classes. Their newspaper was the *Echo* and the annual the *Sequoia*. There was the Associated Student Body with a full complement of officers (newly elected every school quarter), song leaders, yell leaders and clubs. The parents and elders in town got involved with the school by being helpers and advisers to the Girl Reserves, Campfire Girls, Boy Scouts (Troop 10) and the Hiking Club. And for the grown-ups, there was the PTA.

Taken from the pages of the *Sequoia* school annual, this photo shows that quarter's student body from 1926.

The students had the old-style desks where the seat made the back of the writing desk behind it. Their lockers were the cupboards (two students per cupboard) and even the big stove in the kitchen (two ovens, two students per oven). The classrooms were heated by oil stoves.

Many of the old students are still around the river area: Pete Benelli, Frances (Lambert) Saunders, her sister Ella Kinman, Warne Lark, Norm and Ras Jensen, Edith (Grider) Coon, George Guerne, Lenabelle Miller, Edna (Trowbridge) Jensen and Merle (Wescott) Cruikshank. These are just a few of the some two hundred students who attended Guerneville Junior High School over fifty years ago.

The year 1926 was one of all new personnel. In that year, students also published their only yearbook, and it was the last year of junior high. The new elementary school absorbed the seventh and eighth grades, and the ninth returned to Analy High School in Sebastopol.

CHRISTMAS IN GUERNEVILLE 1879, REMEMBER?

The Paper, *December 28, 1979–January 3, 1980*

Christmas. The holiday season of mixed emotions. Even Ol' Timer seemed groused at running around, shopping in town yet enjoying the sight of decorations.

I was standing with him in front of Neeley's Shop (Big Bottom Market, as of 2012). He was wearing his same old mackinaw and navy knit cap; his hands were thrust in his coat pockets against the cold.

"Didja go to that town Christmas party at the Odd Fellows?" he queried.

"No," I answered. "How about you?"

"Nope. Ya know, those parties used to be every year, then they quit 'em—at least thet's what Pa told me." He rambled on, "When Pa was a kid, everybody in town showed up, but I guess the changin' times let it die out. He said it was even more fun than Christmas at home with just the folks. Ya know, all yer friends was there and there was a big tree, too."

I was imagining Guerneville as a lumber town while Ol' Timer painted his picture to me: Christmas 1879 in Guerneville. What was it like in the days of Ol' Timer's Pa? My answer was in old newspapers.

The weather was cold and damp that December, with morning fogs hugging the canyons. Frosts lasted for weeks in protected areas. The streets were muddy in low spots, packed hard in others; the summer dust from lumber teams had been washed off homes, off trees and out of the air by the November rains. The whitewashed buildings were white again.

The lumber mills had shut down for the winter season. Loggers and mill hands were given back to their families. The school had closed for the winter vacation for two months, releasing children to the outside world.

At the end of November, a diphtheria epidemic was presently taking the lives of youngsters—one a week. But an "unknown force" held sway in town; no child was lost to the disease for a week before and a week after Christmas.

A turkey shoot was held to add a little excitement to the coming of Christmas.

The Schloss store had goods of all kinds shipped in by rail to suit all ages. "An elegant display of choice Christmas goods has been opened," stated a newspaper.

People and families across the river could still ford it to share in the town's festive mood. As the big day got closer, the grown-ups put up a Christmas tree in Taggart's Hall (now an empty lot located west of IOFF Hall). With

"S of T" Independence Hall once stood at today's First Street. The building to the far left, the Riverlane Resort Office, still stands today.

decorations and unlit candles festooning the branches, the tree was placed on a revolving stand.

On Christmas Eve, a ball was held in Independence Hall (now an apartment complex on First Street), attended by some forty couples. Dancing to Mr. McBee's band, the dance lasted until midnight, when John Tolks, local hotel owner, set out one of his excellent suppers.

The big day arrived: Thursday, December 25, 1879. The weather was colder; frost coated the world white. Ice-covered ponds and puddles and formed along the river's edge. Light blue smoke issued from chimneys to join the fog.

Ovens stuffed with turkeys stuffed with dressing created zephyr aromas to mingle about the neighborhood.

In the late afternoon, the townsfolk with their bundled bodies gathered at Taggart's decorated hall bearing bundles. The gifts were placed under the tree that slowly revolved with lit candles. Finally, Santa Claus arrived and distributed presents to all. The party passed, and the bundled bodies headed home through the chilled evening.

Mother and child climbed into beds as fathers banked the fires. The fog grew thicker in the valleys. Guerneville tucked away Christmas 1879.

Diggin' Up Local History

The Paper, *December 7–13, 1979*

I was shaking off the morning frost with a cup of coffee at Pat's. Lenabelle Miller, Warren Storey and a couple other natives had drifted in and out. I picked up bits of local history from our conversations and scribbled them down when they left.

I was just getting ready to leave when Ol' Timer walked in, bundled up in his old knit cap and mackinaw; the cold nipping at his face added a few more wrinkles.

"Hi, John," he greeted.

"Howdy," I returned.

"It's as cold as a grave digger's heart. Oh, see ya been makin' notes again."

"Yeah," I answered. "I've been over to the mortuary talking to Wendell Joost, digging up facts about our pioneers. It's a grave situation," I punned.

"Well, now that's an interesting subject. Our graveyard's got a couple of odd things in it," he chuckled over his coffee, "and some not in it."

Dang it! He did it again. He got my curiosity really aroused. My old friend gave me some basic facts to start my search. The results of my quest are four anecdotes.

A while back, I wrote an article about an unknown man. He was found up Hulbert Creek near Old Cazadero Road with a shoemaker's awl, cobbler's thread and a ball of beeswax in his coat pocket. There was no identification; no one knew him. He had died some five or six months before being found. This cobbler was buried at the scene. A few months passed. The man was dug up, and his mortal remains were reinterred in our cemetery on the hill. His grave is unmarked and unkept, just a common-appearing plot of ground. Where did he come from? Did he meet foul play? I often wonder about this man.

The grave site of longtime resident Albert S. Bierce is marked with the Eighteenth Ohio Light Artillery in the Civil War. His plot has a cement curb, not vine covered, surrounding his grave and one alongside. This neighboring grave is empty and will remain empty until his brother is found. Albert Bierce is the brother of Ambrose Bierce, the writer and correspondent of the late nineteenth century.

It is well known that Ambrose, when in his early seventies, went to Mexico in 1914 during that country's revolution to be the first of this century to report on

Schoolteacher Mr. E.R. Lillie, who passed away at the young age of twenty-four, was the first to be buried in Guerneville's Pioneer Cemetery.

the conflict for the newspapers. He disappeared during that war and has not been heard from or seen since. All investigations have been found wanting. Albert Bierce lies alone, and the grave lies waiting.

The second undertaker of Guerneville was R. Noel Tunstall. He chose this occupation in 1906 and retired in 1946. The tall, slender Tunstall lived to the ripe age of ninety-three. At the time of his death, there arose a family feud—where was Noel to be buried? Both factions wanted him. The end result is there are two headstones with Noel's name engraved. The question still remains: under which stone lies Noel?

There are in front of Centennial Savings and Loan a couple of fenced-in flower plots. The one on the corner of Main and Church Streets has a brass plaque commemorating George Bernard "Mac" McPherson. (Update: The plaque is now located at the corner of Main Street and Armstrong Woods Road in front of Community First Credit Union.) Mac was quite the man about town. For years, he swept the streets of Guerneville, keeping his town tidy. In 1975, he became known nationwide when he received an award from Lady Bird Johnson's Beautify America and was in the New York newspapers. Mac passed on in 1977 at age eighty-nine. His memorial is in the middle of town, but his earthly remains lie in…Coloma!

I laid in waiting for Ol' Timer at our usual hangout to "show and tell" (or, for adults, "bring and brag") what I had found. He showed up as usual for his morning cup. He looked over my story and made a few grunts. Putting down my writing, he said, "You did pretty good, but you don't have one important fact about our boot hill."

"Huh?" I asked.

"You don't tell anybody in this," he continued, "that there was another cemetery here before this one. It was on the hill behind the Catholic parsonage."

"Sonofagun," said I in surprise.

"There were a couple of people planted there when it was moved up to where it is now," he went on. "When you drive through the gate, stay on that drive and pass the cross drive. You'll then see a gravestone on your right alongside the drive—it belongs to Elbert R. Lillie. He was the first to be buried in the new cemetery in May 1875."

He slurped his coffee, eyeing me over the lip of the cup. I just sat there thinking, *I've been dinged again; I'll never top him.*

THE LAST GUERNEVILLE TRAIN

The Paper, *November 23, 1979*

I was walking down Main Street, heading for my morning cup of coffee and conversations with the locals, when I bumped into Ol' Timer. He was standing on the curb in his old knit cap and mackinaw in front of Neeley's (Big Bottom Market, as of 2012). He was squinting into the cold morning fog watching ditch-digging equipment drive by.

"Howdy," he greeted me. "These fellows sure been busy diggin' 'round here. They dug up an old rail down River Road…it's been a long time since the last train left town."

We conversed in small talk, and he left toward home. As I watched him stroll up the street, I said to myself, "Self, you and Ol' Timer are going to put that day, the day of the last train, together."

It happened during the Depression in 1935. Business by rail had fallen off; people were traveling more by auto, and freight was an occasional boxcar. The railroad itself was in dire need of repair. Speed on the tracks had been reduced to twenty-five miles per hour. The Northwestern Pacific Railroad (NWPRR) asked the Interstate Commerce Commission to abandon the Guerneville branch. Request granted. The NWPRR posted announcements in towns along the river stating that November 14, 1935, would be the last train to Duncans Mills.

It was overcast on that particular Thursday. The train, composed of three coaches, a baggage car and an engine, came down from Rio Nido, belching

Locals gather to celebrate the last train, shown here, departing Guerneville, heading for Duncans Mills.

steam and gray smoke through town to the depot on Railroad Avenue (now Main Street) at Mill Street.

The town had declared a holiday. Old people and youngsters alike were out to greet the train. A sign was hung up on the side of the last coach declaring "The Last Round-Up." On the end was hung a double wreath. Frank Gori, a cinema buff, was to take movies, but he couldn't make it. He gave his camera to Ras Jensen to preserve the occasion. Pathé movie news was supposed to be there, but it was also a no-show.

Mortals, morsels and sourmash (plus other beverages) climbed aboard for the trip downriver; the coaches were filled. The people were in a festive mood for the seven and a half miles to the end of the line. At Monte Rio, the crew opened the baggage car for the new passengers. The beer flowed freely.

The cars pulled into Duncans Mills at noon. For the next hour and a half, basket lunches were pillaged and speeches and clapping echoed off the rolling hills. Cameras clicked—history preserved.

I called up Ol' Timer and told of what I had put together. "Well, now," he said, "everybody was in a celebrating mood. Some were sad, others happy—at least on the outside. Marjorie Rickett, she's a Pedroia now, and Red Pool, Mrs. Hembree and another gal climbed up into the engine cab and had their picture took.

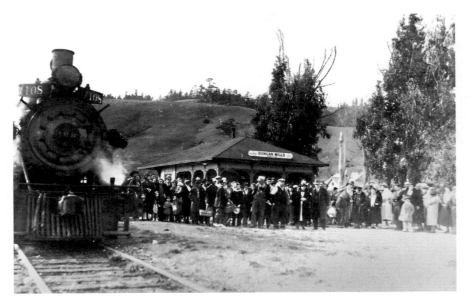

The last train at Duncans Mills, November 14, 1935. Note the picnic baskets in hands.

"The beer sure was flowing," he chuckled. "I remember 'Pa' Starrett with his white moustache wore a big long overcoat and a fedora."

During the gray noonday picnic, the locomotive picked up a few remaining boxcars and recoupled the coaches. Conductor H. Johnson called out "All aboard!" It was 1:40 p.m., the scheduled time to leave for Santa Rosa. The passengers stepped, climbed, struggled and, in some cases, were helped aboard—alcohol was rather popular this day.

People lined the road here and there waving. The train rolled along with its monotonous clickety-click, clickety-click.

Ol' Timer smiled when he told me, "One song everyone sang on the way back: 'Goodbye, My Lover, Goodbye.' And when we left Monte Rio, Charley Peck and Jack Brown missed the train—guess the beer got to them."

The Monte Rio fire engines were at the depot with sirens wailing farewell. The melancholy goodbye was even worse at Guerneville. Horns and bells sounded, hankies waved as the train disappeared around the bend at the lumberyard. It left tears on cheeks and a few lumps in throats. Engineer Billy Burns didn't help matters any by hanging on the whistle cord until he was way down the track.

About a week had passed since I wrote the above when I met Ol' Timer at Lark's Drugstore. He stopped me and said, "I got to thinkin' about the last train, and I rummaged around my stuff and found this article for you."

He shoved a piece of old newsprint into my hands. It was a letter to the editor of the *Guerneville Times* written by E.H. Nervo:

November 22nd, 1935
As the last train left Duncans Mills on Thursday, November 14th, I purposely watched from the platform of the last car the entire vicinity from Duncans Mills to Fulton and, with eyes rimmed with tears, I dimly saw the dark future of the communities along the line to be torn up.

No more do the hills echo with the deep music of the locomotives' whistle, the rush, the power, and the thunder of the speeding trains. The steel rails will soon be ripped up. Stations are deserted. The iron horse is silent. Gone is a dependable transportation agency, a good citizen and community builder. Gone...

ABOUT THE AUTHOR

John C. Schubert was born in San Francisco in 1938 and was raised throughout the Bay Area and San Gabriel Valley. He spent his childhood summers at his grandfather's old seasonal home in Guernewood Park. In the 1960s, Guerneville became his permanent home. He is a retired Sonoma County sheriff deputy, a former U.S. Marine and a local writer and historian of some note to the Russian River area. He has three sons and four granddaughters and lives in Guerneville with his life companion, Sarah.

Visit us at
www.historypress.net
...
This title is also available as an e-book